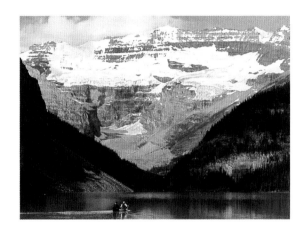

BANFF
NATIONAL PARK

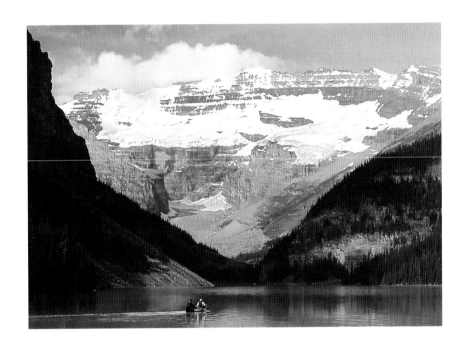

whitecap

Text and photo editing by Tanya Lloyd Kyi
Edited by Elaine Jones
Proofread by Lisa Collins
Cover and interior design by Steve Penner
Typeset by Jacqui Thomas
Printed and bound in China by WKT Company Limited.

National Library of Canada Cataloguing in Publication Data

Kyi, Tanya Lloyd, 1973–
 Banff National Park
 (Canada series)
(hardcover)—
 ISBN 1-55285-328-4
 ISBN 978-1-55285-328-3
(paperback)—
 ISBN 1-55285-792-1
 ISBN 978-1-55285-792-2
1. Banff National Park (Alta.)—Pictorial works. 1. Title. II. Series:
Kyi, Tanya Lloyd, 1973- Canada Series.
FC 3664.B3K94 2002 971.23'3203'0222 C2002-910079-8 F1079.B5K94 2002

The publisher acknowledges the support of the Canada Council and the Cultural
Services Branch of the Government of British Columbia in making this publication
possible. We acknowledge the financial support of the Government of Canada through
the Book Publishing Industry Development Program for our publishing activities.

For more information on the America Series and other titles by Whitecap Books,
please visit our website at www.whitecap.ca.

In 1857, the Hudson's Bay Company held a monopoly over much of the Canadian prairies. Fort Victoria was not even two decades old, and British Columbia was years from becoming a province of Canada. The Rocky Mountains loomed, fortress-like, a seemingly impassable barrier to settlement in the west. At this time, the Royal Geographical Society, an organization that funded exploration throughout the British Empire, sponsored John Palliser to explore North America. First and foremost an organization dedicated to science, the society selected three men to accompany Palliser—mathematician John Sullivan, botanist Eugene Bourgeau, and geologist and doctor James Hector.

When they reached the spine of the continent, the explorers split into three groups and searched for the most accessible passes—the best routes for building a railroad and bringing generations of homesteaders. It was James Hector's group, with the help of local Stoney guides, that first travelled in the shadows of Castle Mountain and Mount Rundle and named these landmarks.

And so the history of the Rocky Mountains and the history of Canada accelerated. No longer were these slopes the sole domain of native hunters and traders. By the 1880s, William Cornelius Van Horne and his builders and engineers were laying tracks towards Kicking Horse Pass. His workers stumbled upon Cave and Basin Hot Springs in 1883, sparking a land ownership dispute that in turn prompted the creation of Canada's first national preserve. The federal government established Rocky Mountains Park in 1887 and steadily expanded it, eventually bestowing the name now famous around the world: Banff National Park.

Today part of a UNESCO World Heritage Site, the wilderness of Banff remains much as it was when James Hector charted it. To the ancient peaks, the changes of little more than a century are hardly noteworthy. And for the millions of visitors each year who wander some of the 1,600 kilometres (1,000 miles) of trails within the park, who gaze up at more than a thousand glaciers, part of the thrill lies in seeing the land exactly as it was before the nation of Canada was born.

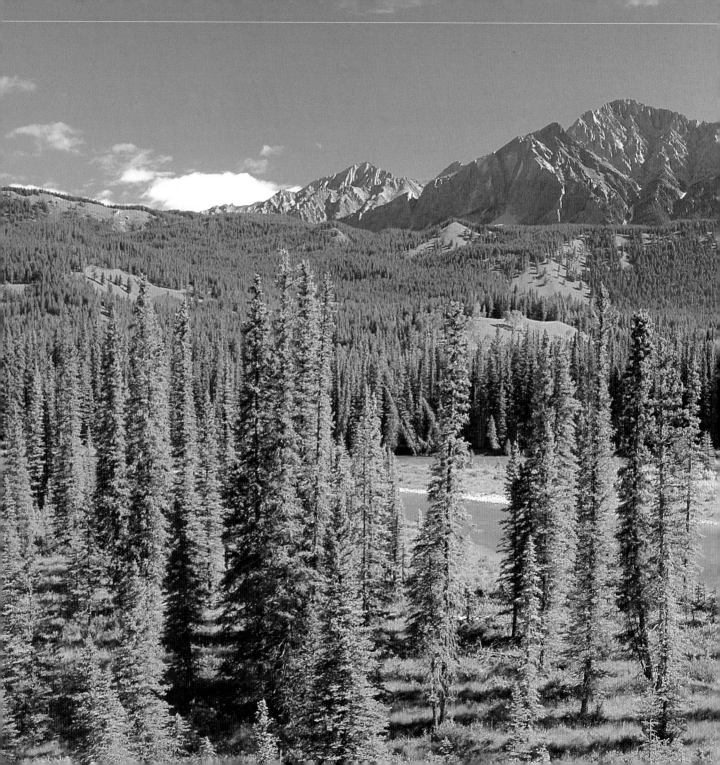

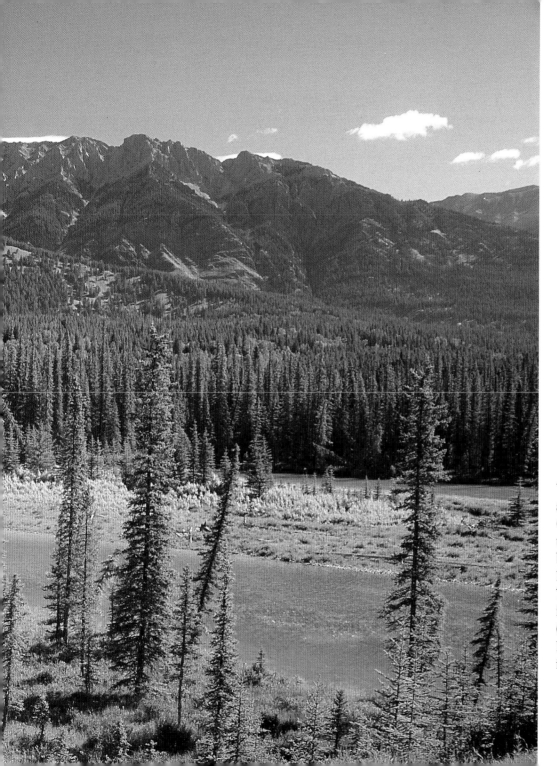

The Rocky Mountains
are part of the
Continental Divide
that runs like a
bony spine through
North America.
The range extends
for 3,220 kilometres
(2,000 miles) from
New Mexico
into Canada.

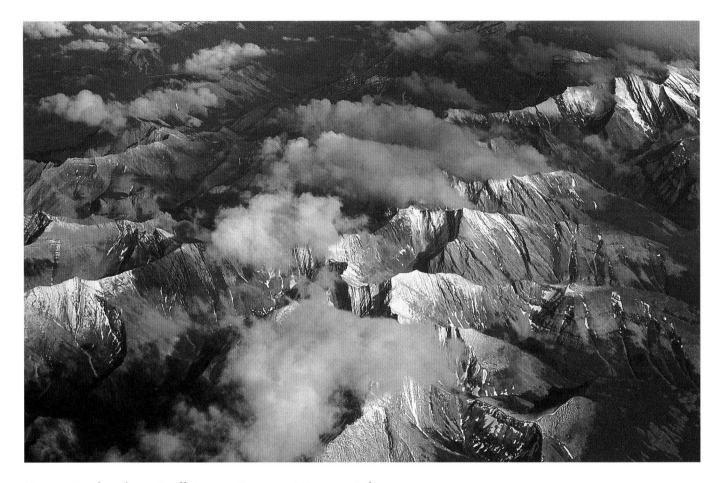

Five national parks—Banff, Jasper, Kootenay, Waterton Lakes, and Yoho—protect the Canadian Rocky Mountains. Together with Hamber, Mount Robson, and Mount Assiniboine provincial parks, these form one of the largest protected areas in the world and a UNESCO World Heritage Site.

Wind and ice were already wearing down other ranges in North America by the time of the Cretaceous period, when colliding plates beneath the earth's surface thrust up the giant peaks of the Rockies.

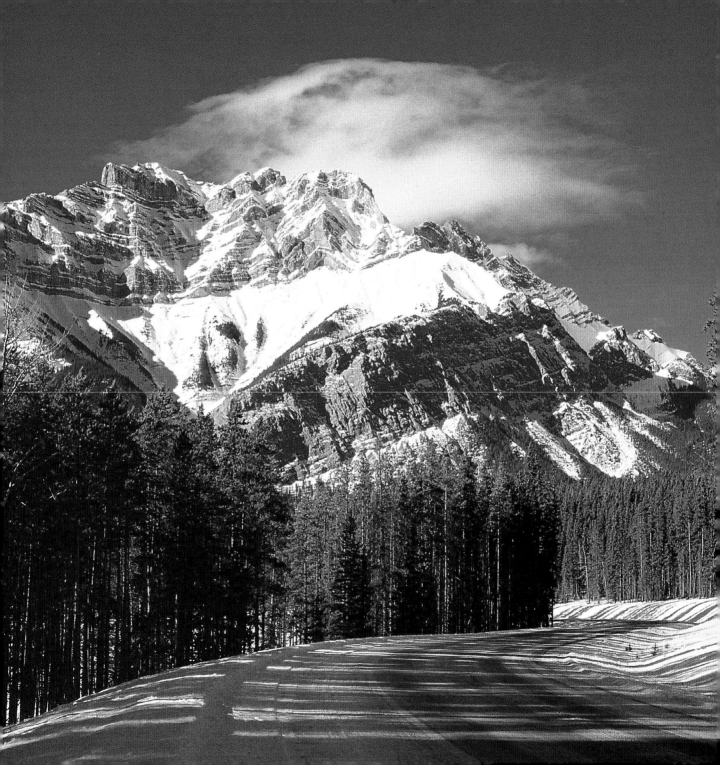

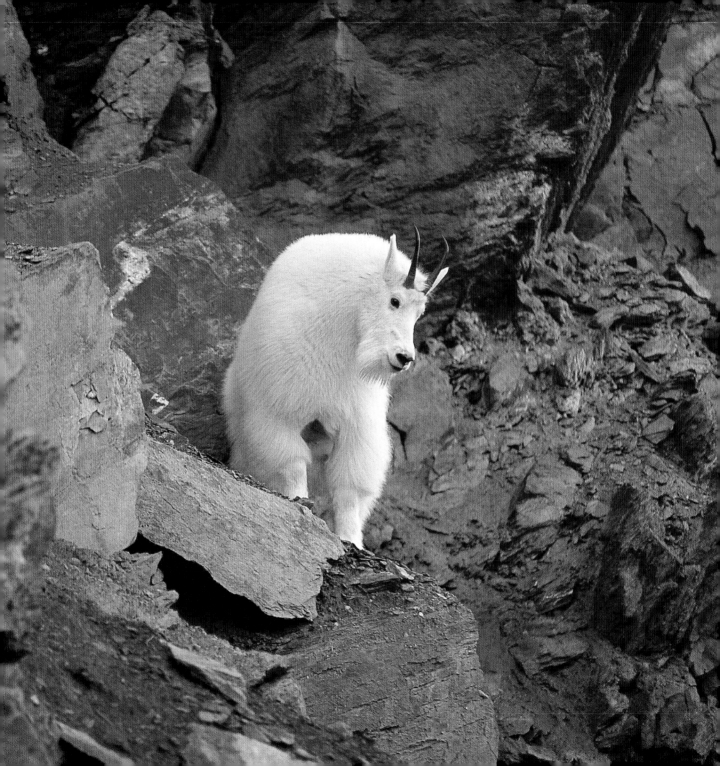

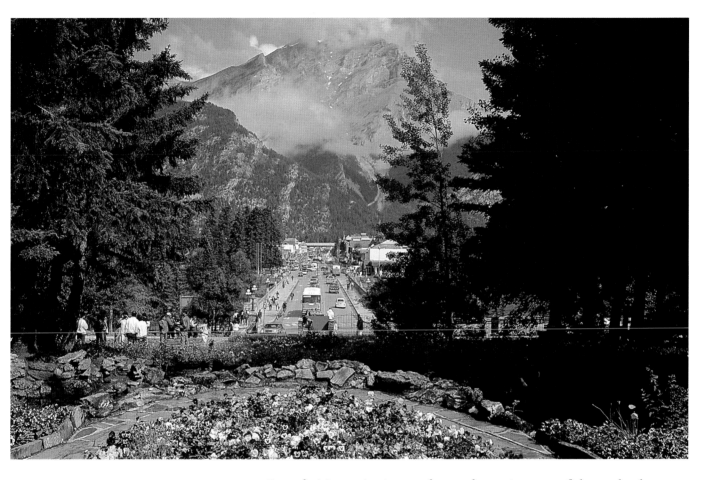

Cascade Mountain rises to the northeast, just one of the peaks that encircle Banff townsite, 130 kilometres (80 miles) from Calgary and within the borders of Banff National Park.

Although a large population of mountain goats inhabits Banff National Park, the animals are seldom seen at the roadside. They populate the high passes, using their uniquely adapted hooves to scale the crags in search of alpine meadow grasses.

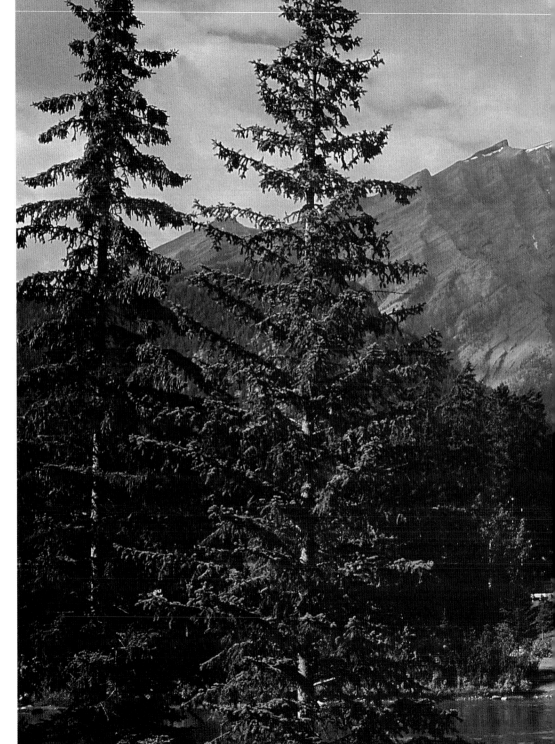

Home to about 7,700 people, Banff is the only municipality within a Canadian national park. Laws intended to protect the wilderness status of Banff restrict the population of the town to less than 10,000.

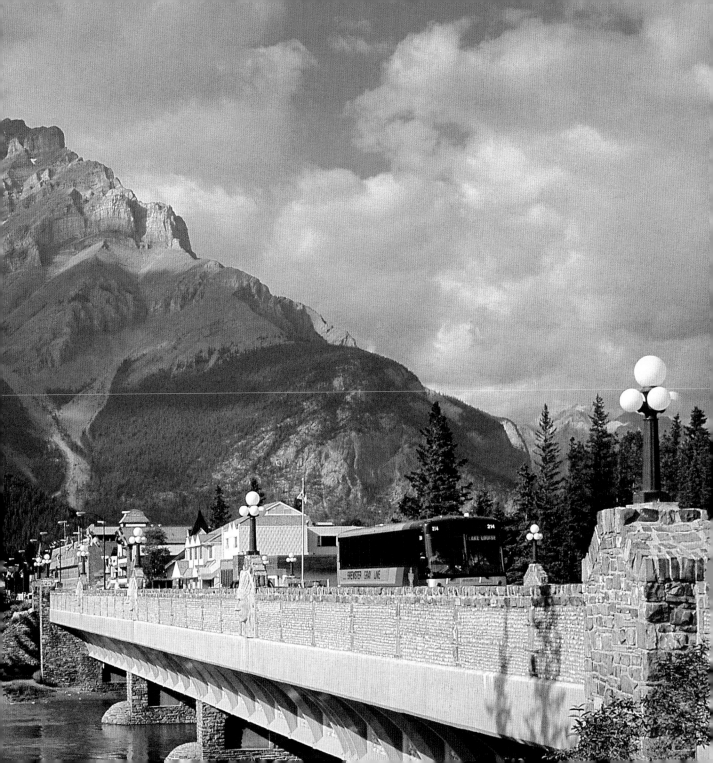

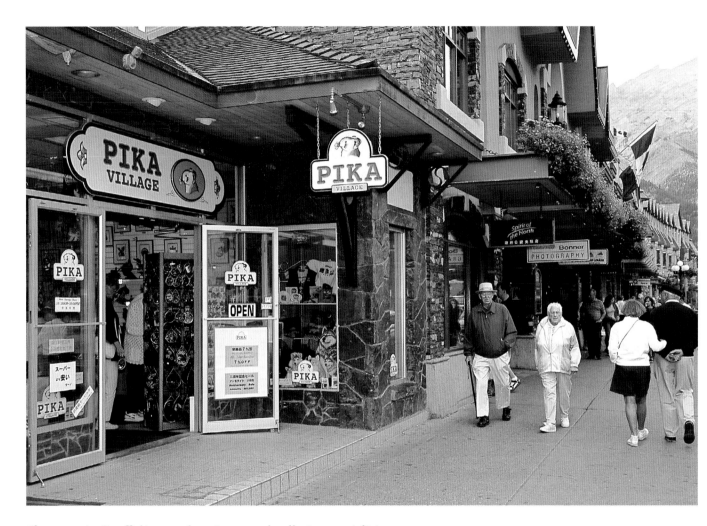

Shoppers in Banff discover boutiques and galleries specializing in Rocky Mountain souvenirs and First Nations art. More than 80 percent of park visitors visit the town each year.

William Cornelius Van Horne, head of the Canadian Pacific Railway in the late 1800s, helped in opening this region to visitors. He is best known for his words, "If we can't export the scenery, we'll import the tourists."

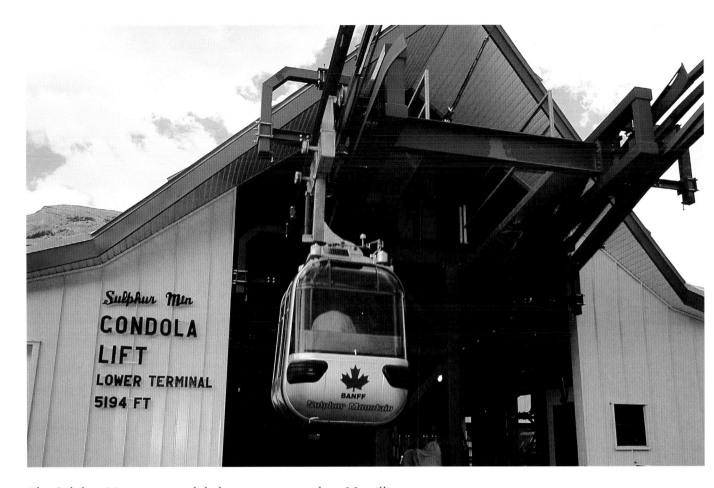

The Sulphur Mountain gondola has swept more than 10 million visitors to the 2,280-metre (7,480-foot) summit. Construction of the gondola began in 1958, after Swiss immigrant John Jaeggi, familiar with similar lifts in his native country, convinced Swiss and Canadian business people to invest in the lift.

The town of Banff is nestled in the montane zone, the lowest of three zones within the park. Here, the snows melt more quickly, allowing the flowers of Cascade Gardens a longer, warmer growing season.

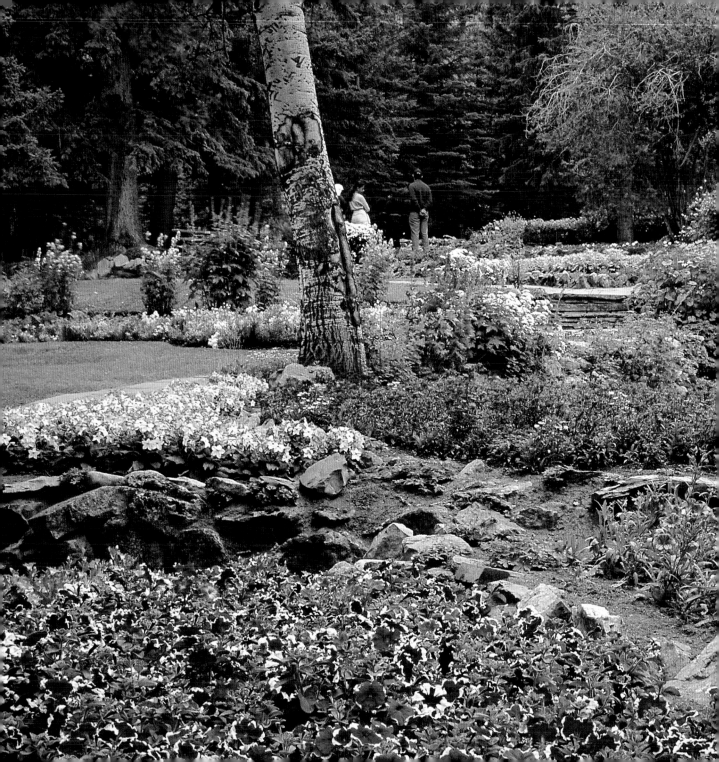

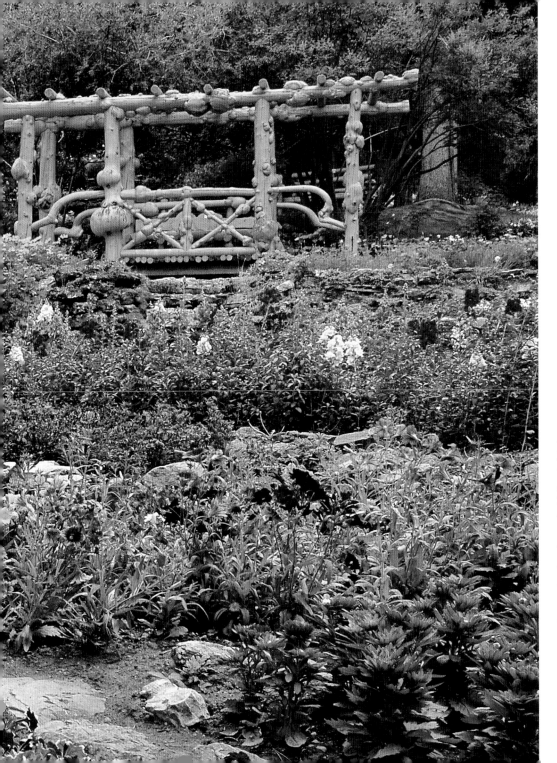

During the Great Depression, the government paid men on relief to build the elaborate Cascade Gardens at the top of Banff Avenue. Tranquil ponds and gently flowing water throughout the gardens make this a favourite retreat from the bustle of the downtown shops.

19

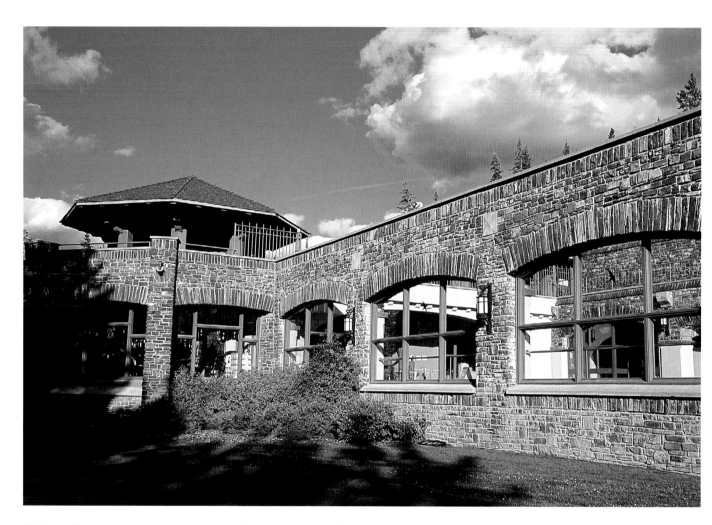

Within the visitors' centre at Cave and Basin National Historic Site, exhibits chronicle the birth and growth of Canada's national parks system, born here in 1885.

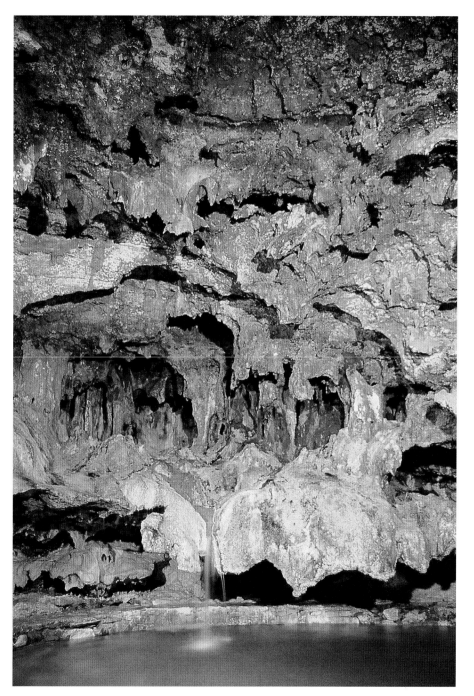

Railway workers Frank McCabe and William and Tom McCardell stumbled upon these caves in 1883 and called them "some fantastic dream from a tale of the Arabian nights." The area was established for public use two years later, due, in part, to a dispute over who owned the rights to the hot springs.

Rain and meltwater sink into the earth in Banff National Park, descending three kilometres (two miles) below the surface. Heated by molten rock, the water —now enriched with minerals and pressurized by the heat—rises to form the hot springs within the park.

FACING PAGE–
The CPR built the Banff Springs Hotel in 1888. The luxurious, castle-like resort was completely redesigned after a fire in 1927 and now offers more than 700 guest rooms.

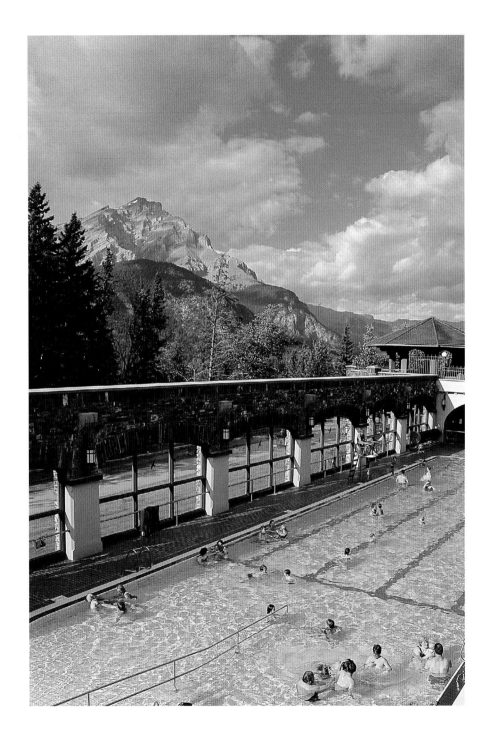

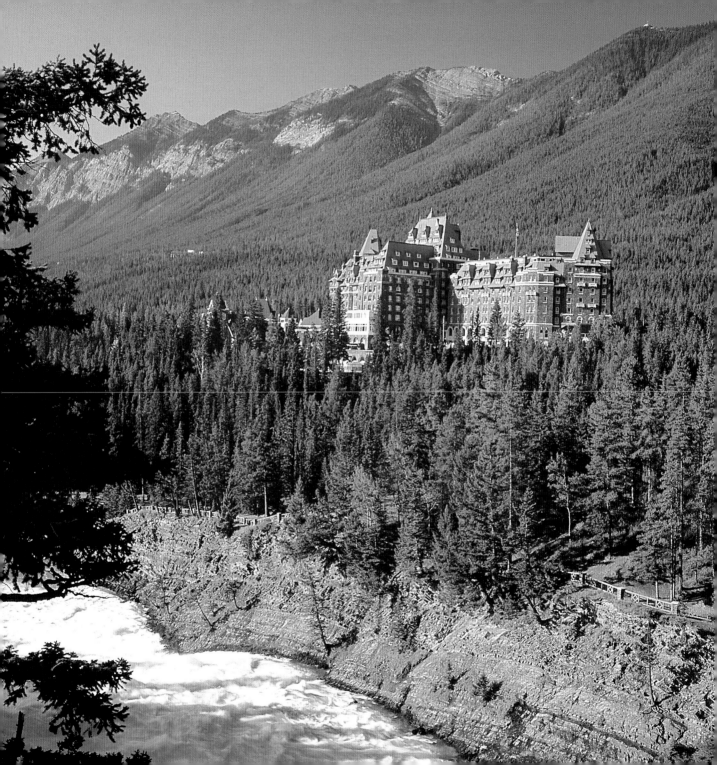

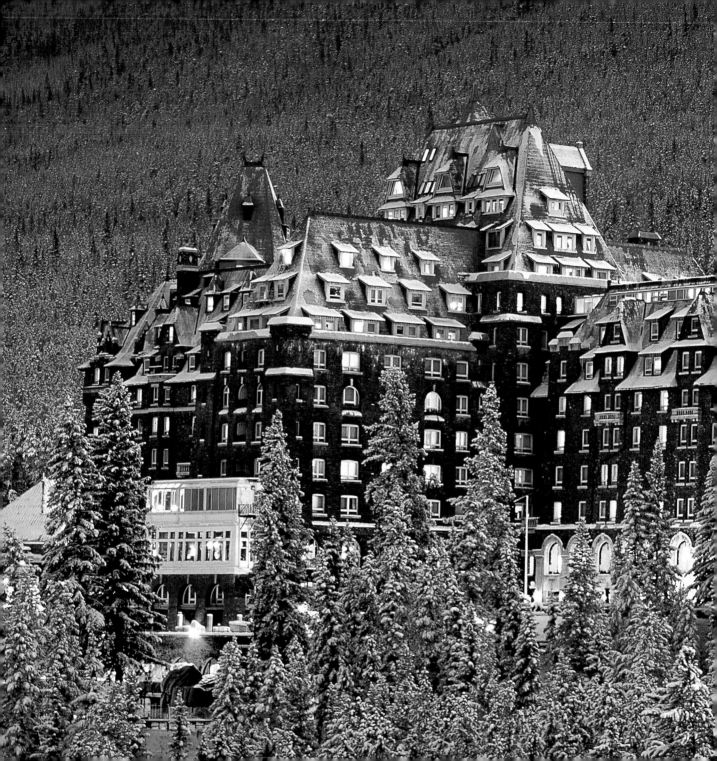

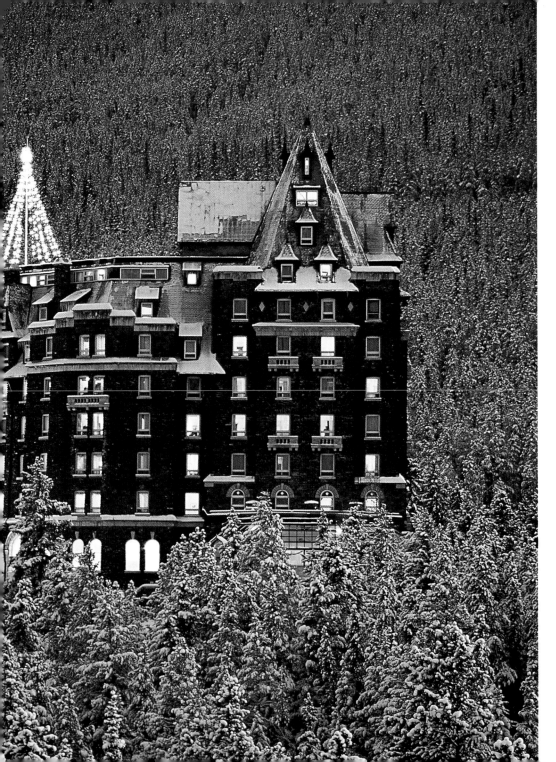

Facilities at the Fairmont Banff Springs Hotel include shops, restaurants, a saloon, a bowling alley, mini golf, an ice rink, and a newly renovated spa area. If the surrounding park wasn't so spectacular, visitors might never leave the resort.

The Bow River flows from Bow Lake, 2,000 metres (6,560 feet) above sea level in Banff National Park. Yet much of the river water originates from the Pacific Ocean — clouds from the coast sweep east until they hit the Rockies, depositing rain and snow that, along with glacier meltwater, forms the region's rivers and lakes.

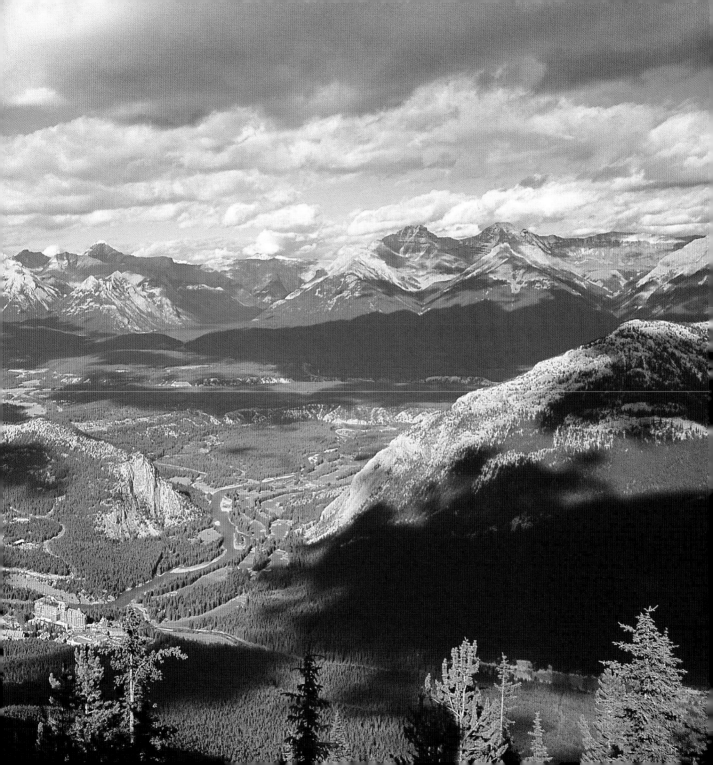

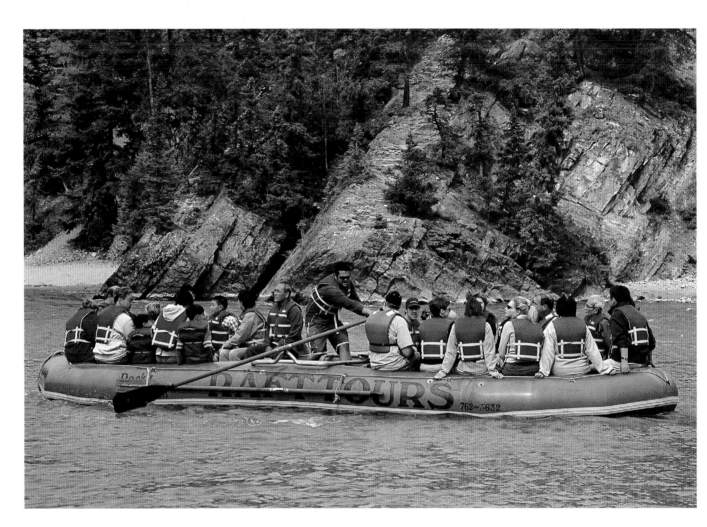

Rafting trips take travellers from the eddies of the Bow River to class three and four rapids within the shale canyon walls. Outside the park, the Kananaskis River provides less hair-raising routes, while the rapids of the Kicking Horse River are reserved for the adventurous.

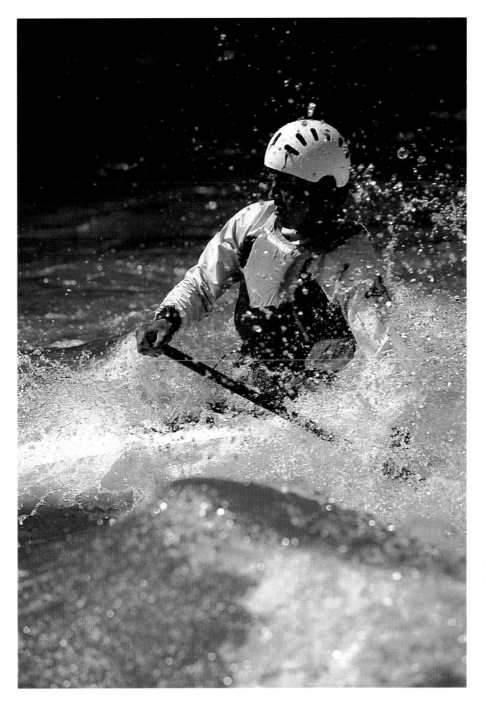

Paddlers of all levels find excitement in the rivers of Banff National Park. Novices enjoy the swift water in inflatable kayaks, while experts test their skills in the whitewater.

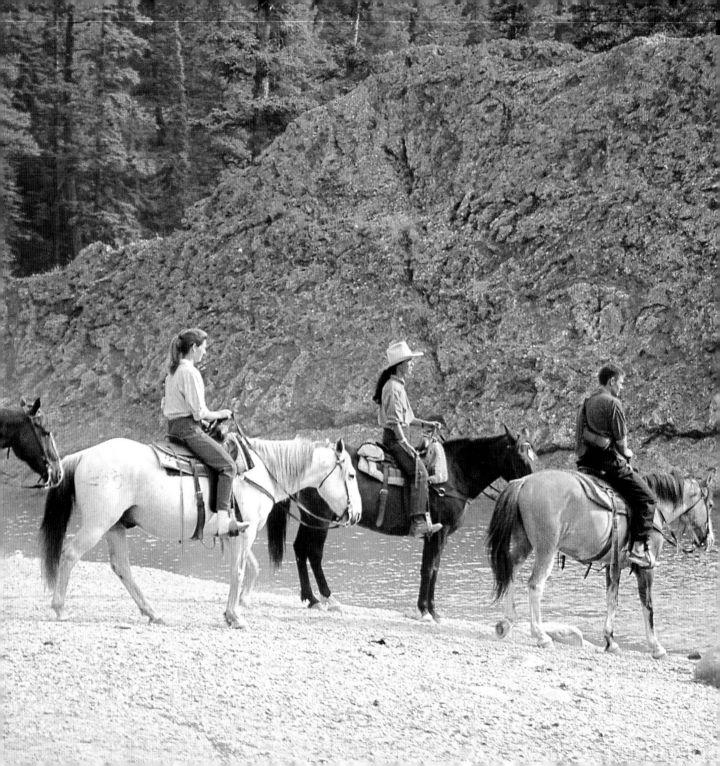

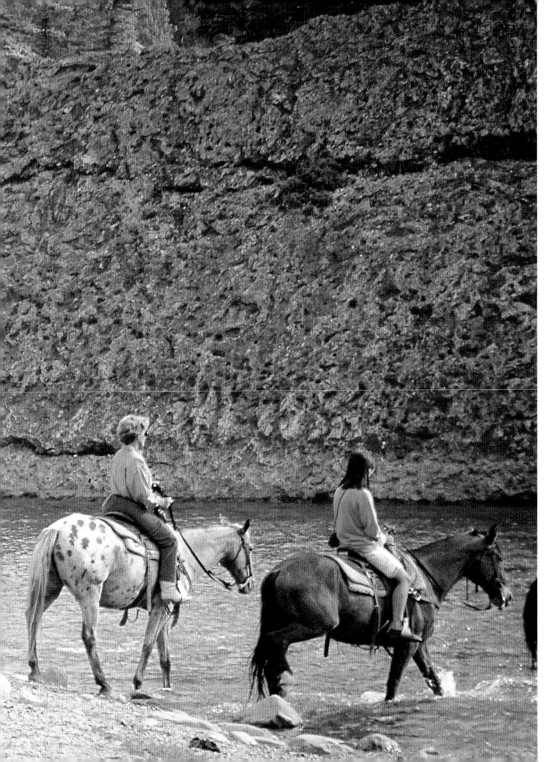

Guides lead riders across the Spray River within Banff National Park. While novice and intermediate riders enjoy the route through the river valley, more experienced riders can choose a three-hour loop through the Bow Valley or a multi-day journey through the mountain passes.

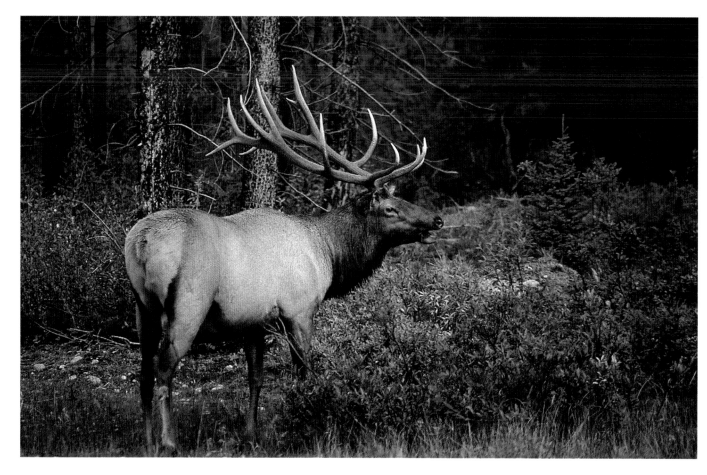

Rocky Mountain elk are also known as wapiti, a name drawn from a
Shawnee word meaning "white rump." About 3,200 of the animals
wander the park, and more than a third of these inhabit the lower
Bow Valley near the town of Banff.

The Banff Centre is dedicated to the arts, leadership, and local
culture. Each year, the arts program offers intensive workshops
and residencies for professionals, including writers, actors, visual
artists, multi-media specialists, and aboriginal artists.

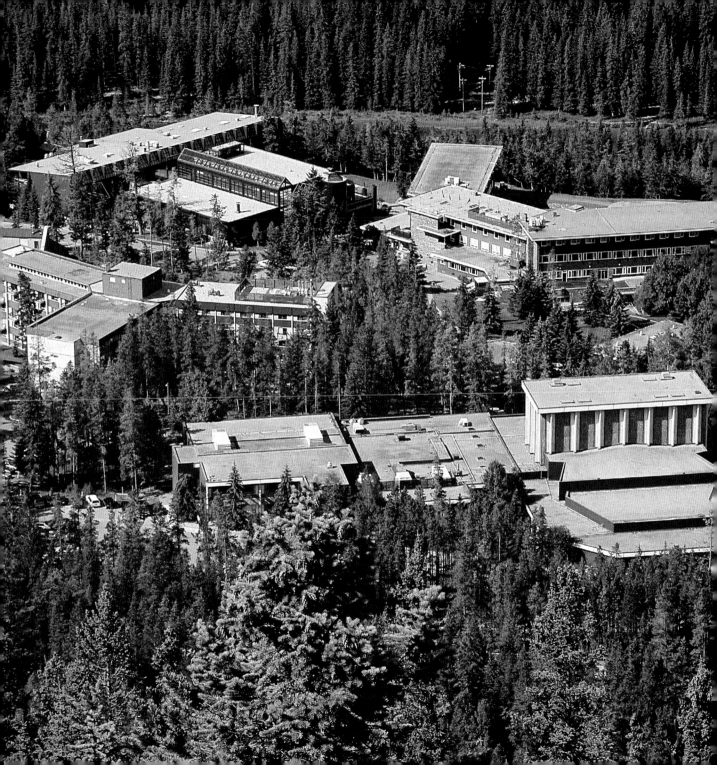

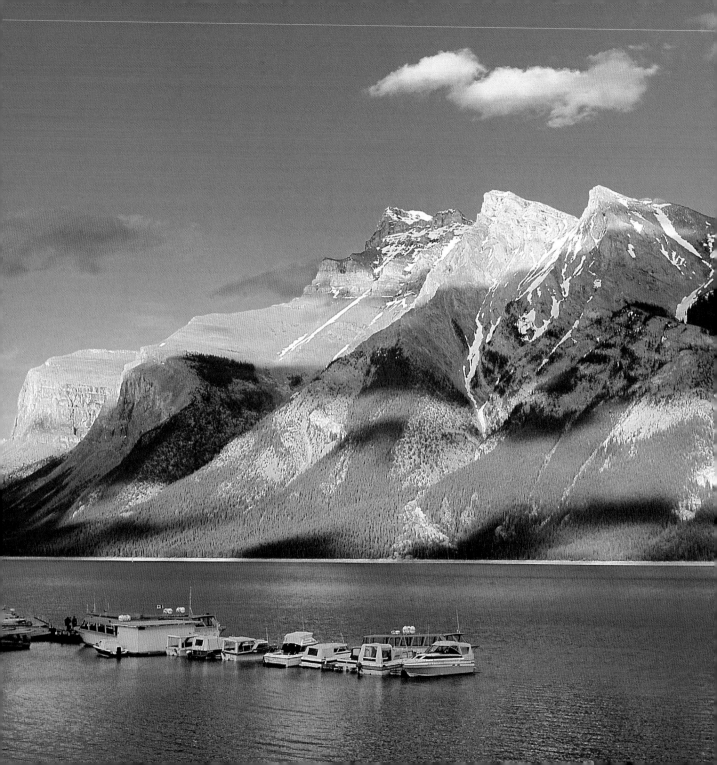

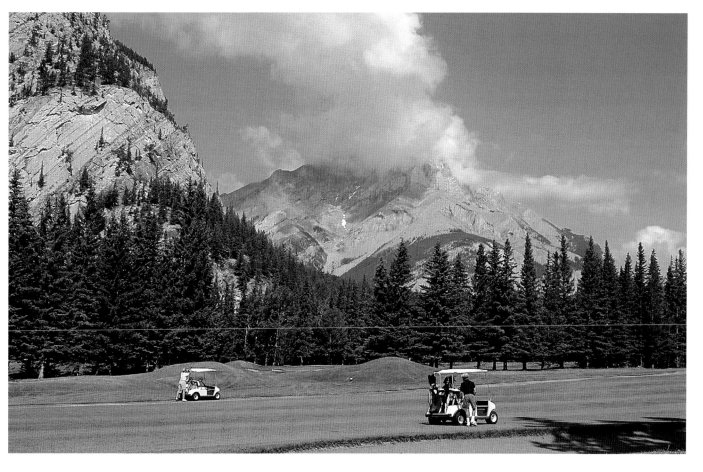

Landscape architect Stanley Thompson designed the Banff Springs Golf Course in 1928. Golfers find the usual hazards, as well as a few surprises—elk and other wildlife are often spotted on the 27-hole course.

Twenty kilometres (12 miles) long and two kilometres (1 mile) wide, Lake Minnewanka is the largest lake in the park and a favourite destination for anglers. *Minnewanka* is a First Nations word recorded by early explorers, meaning "Lake of the Water Spirits."

Winter temperatures have frozen the waterfalls in Johnston Canyon, leaving only the crystal blue pools exposed. A cross-country ski trail follows the summer hiking route to this site.

FACING PAGE—
The rushing meltwater of Johnston Creek has carved a canyon into the soft limestone of the mountainside where there are dolomite outcroppings, resistant to erosion, ledges form and waterfalls cascade over the rock.

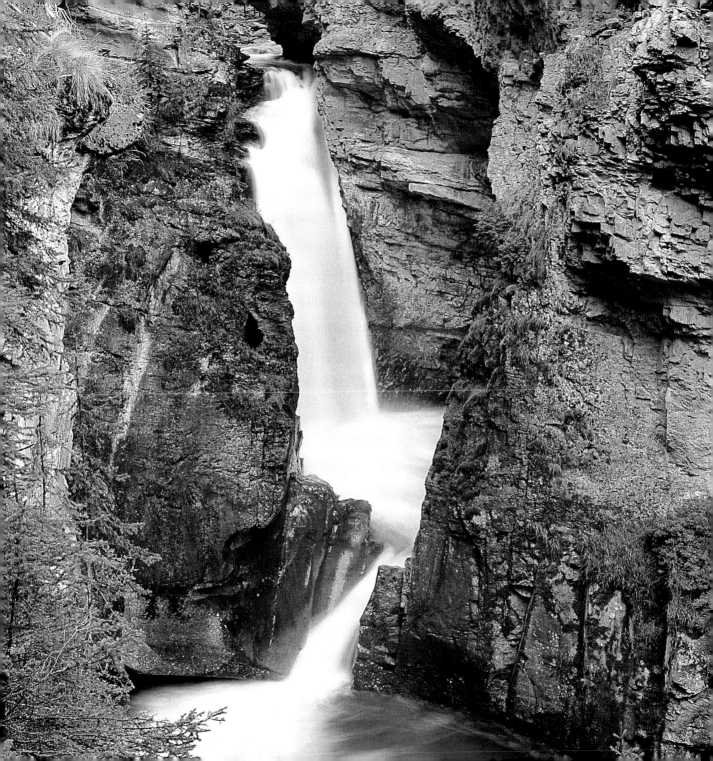

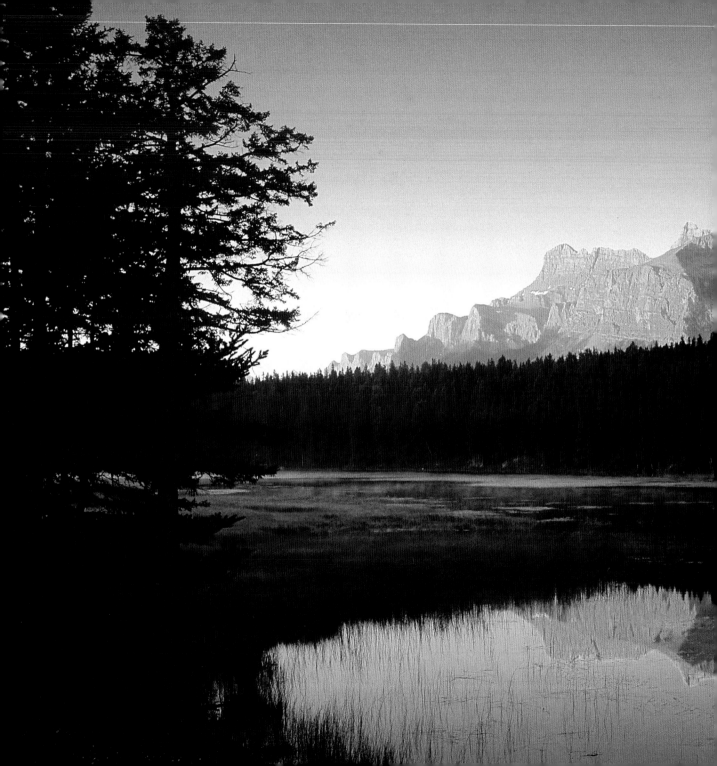

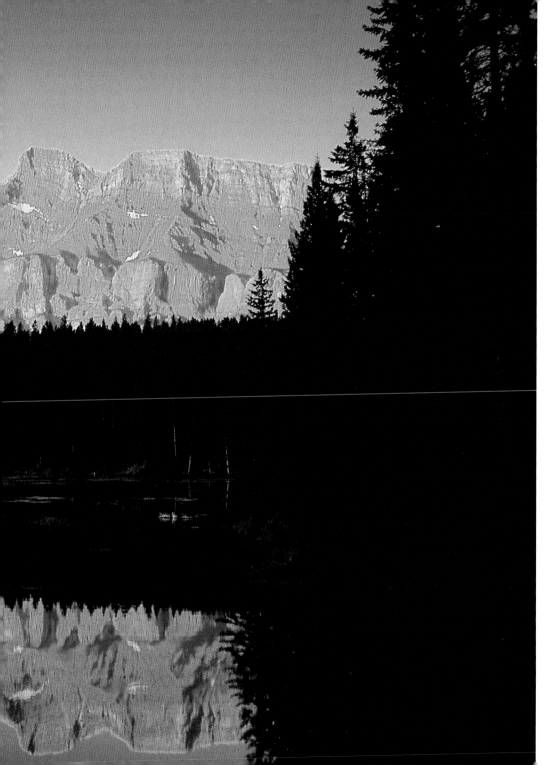

When World War I began, the Canadian government declared thousands of recent European immigrants enemy aliens. About 600 were interned at camps within Banff National Park. Subsisting on low rations and paid 25 cents a day for their work, the men in the camps helped to build the first road from the town of Banff to Lake Louise. The camps were closed in 1917.

Growing up to three metres (10 feet) high, fireweed blooms throughout the summer months in the meadows of Banff National Park. The plant is named not for its colour, but for its quick appearance after forest fires.

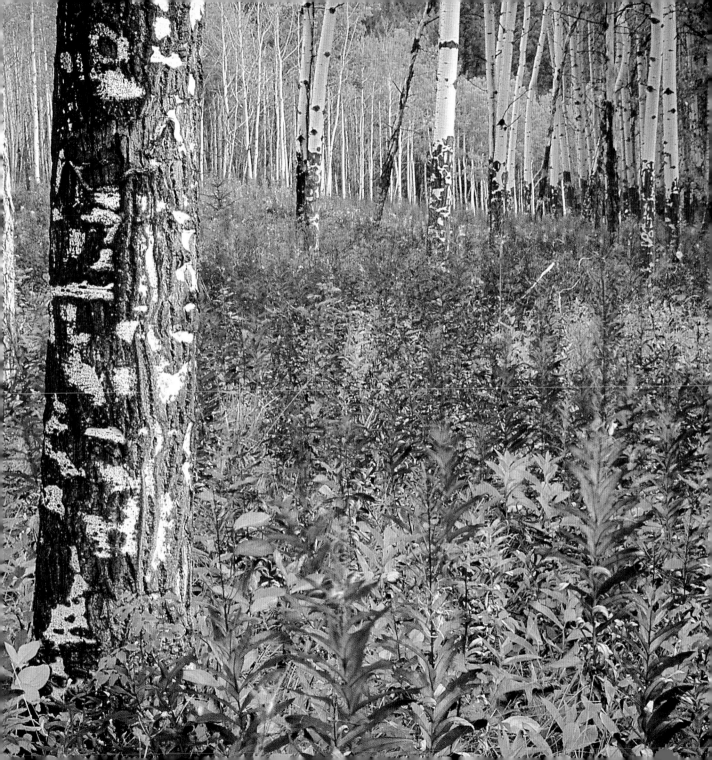

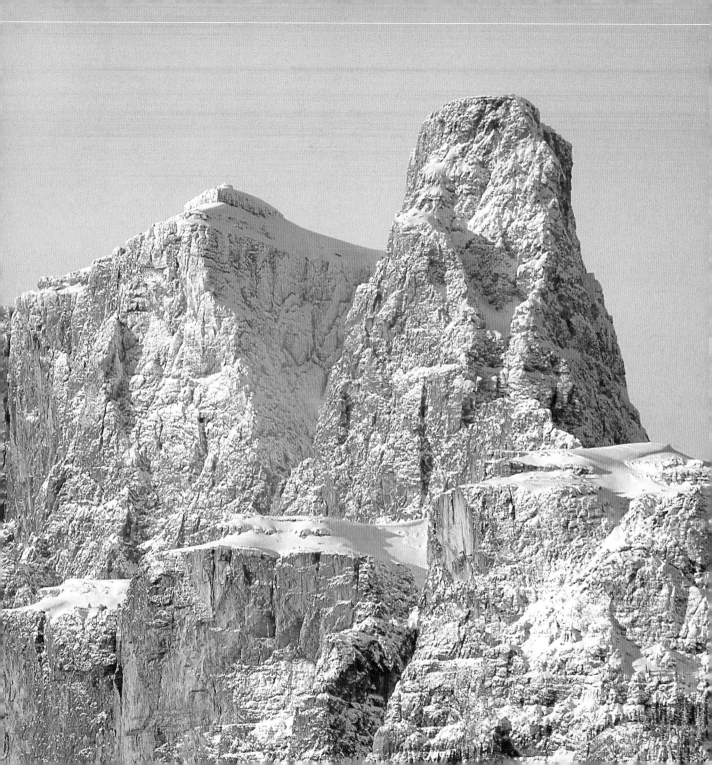

Lake Louise is one of the most popular stops for sightseers within the park. At the visitors' centre, exhibits reveal 600 million years of geological history, from the ancient movements of the earth's crust to the glaciers of the last ice age.

FACING PAGE—
One glance at the formidable ramparts of Castle Mountain explains its name. After World War II, this mountain was temporarily known as Mount Eisenhower. One of the peaks still bears the American president's name.

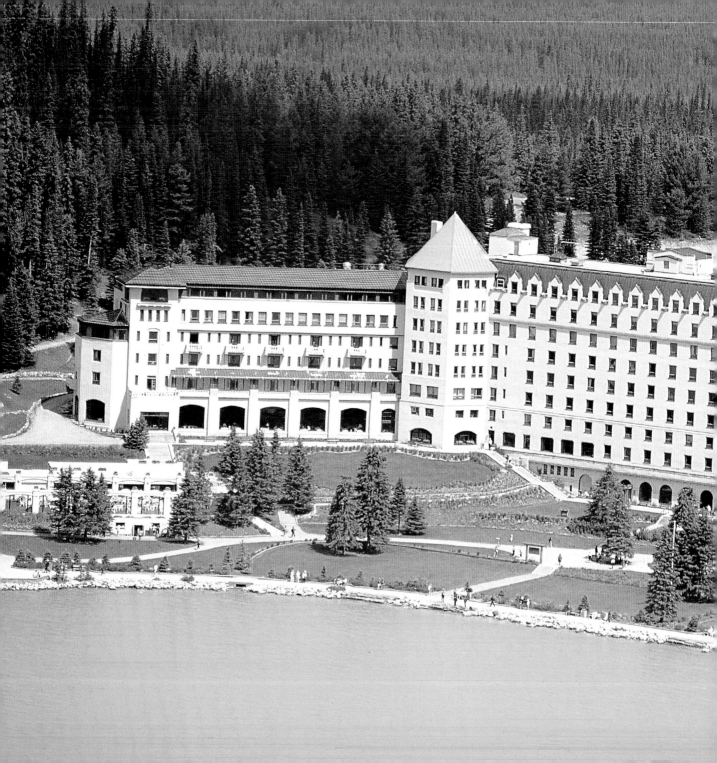

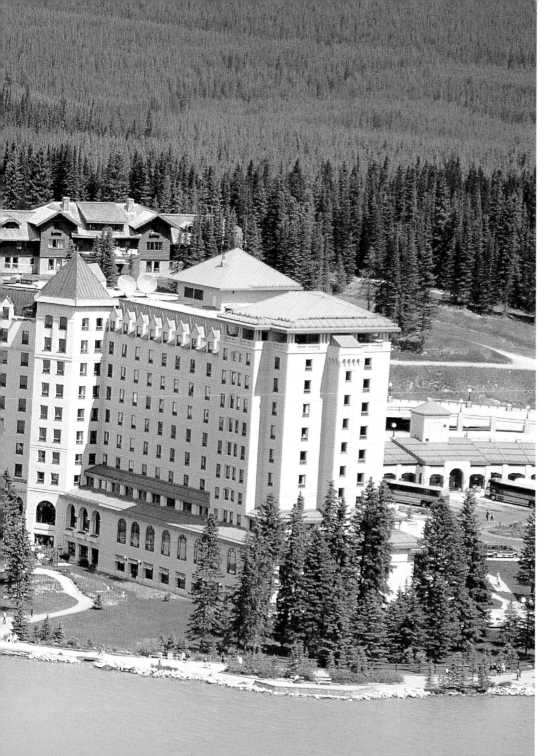

The Fairmont Chateau Lake Louise began as part of William Cornelius Van Horne's vision for the Rockies. He commissioned the hotel "for the outdoor adventurer and alpinist" two years after the railway completed the nearby Banff Springs Hotel.

45

A popular viewpoint draws a crowd of visitors hoping to capture
Lake Louise on film. A gateway to the park's backcountry, Lake Louise
serves as a base for hiking, fishing, dogsledding, heli-skiing, sleigh
riding, and more.

A profusion of wildflowers bloom in the subalpine meadows each
summer, from delicate mountain lilies and white cow parsnip—
a favourite of the grizzly—to hardy fireweed.

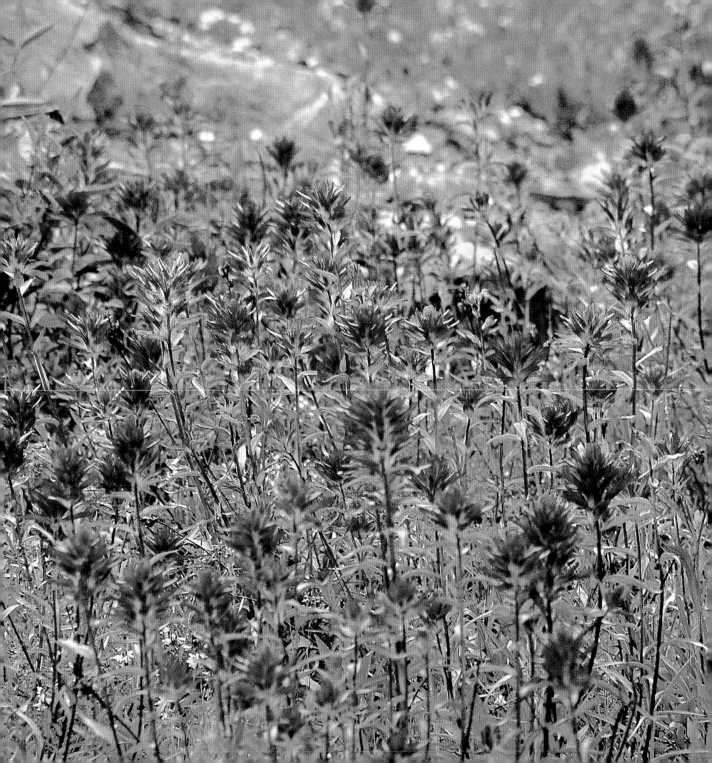

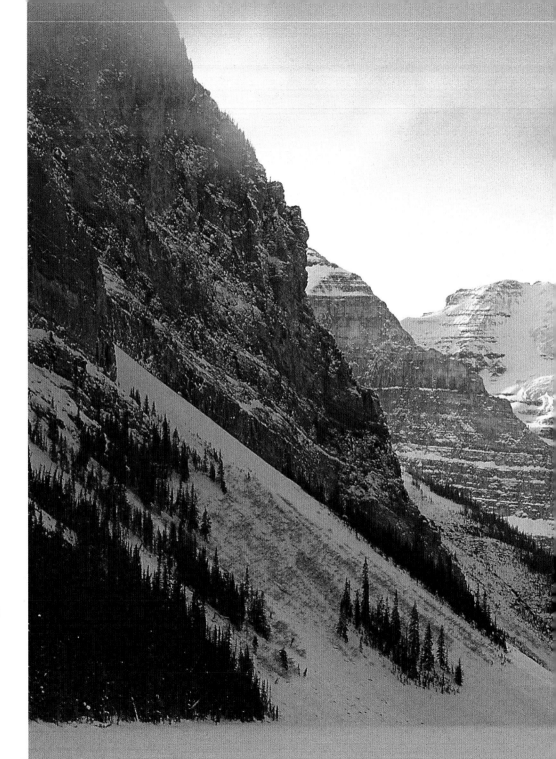

Skiers flock to Lake Louise each winter to experience some of the world's best alpine skiing. Along with bowls of untouched powder, skiers and snowboarders can choose from more than 100 routes on four mountain faces.

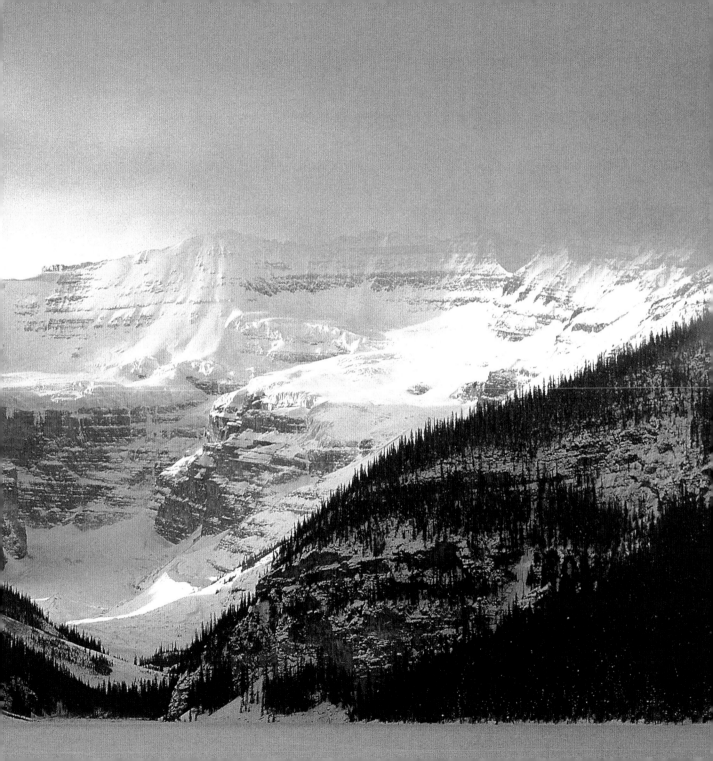

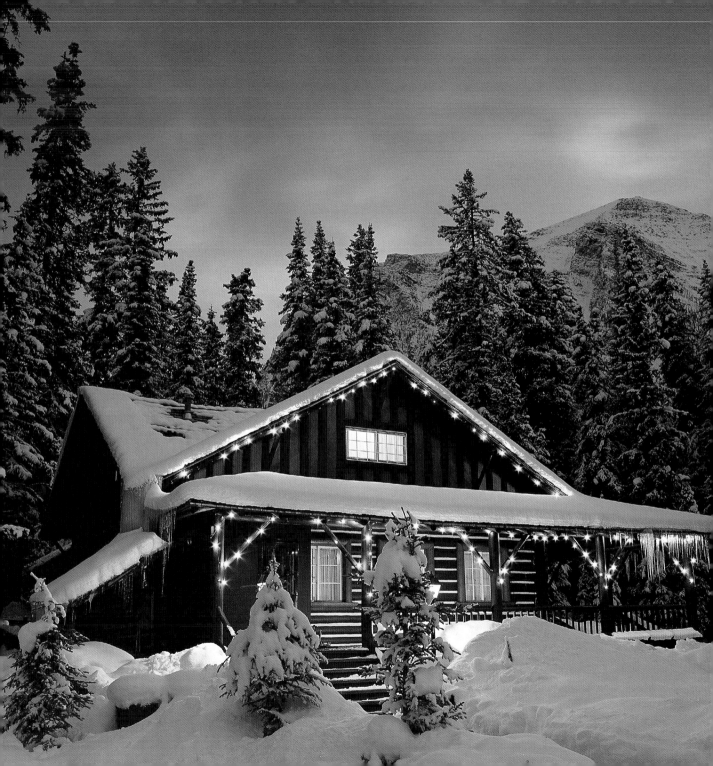

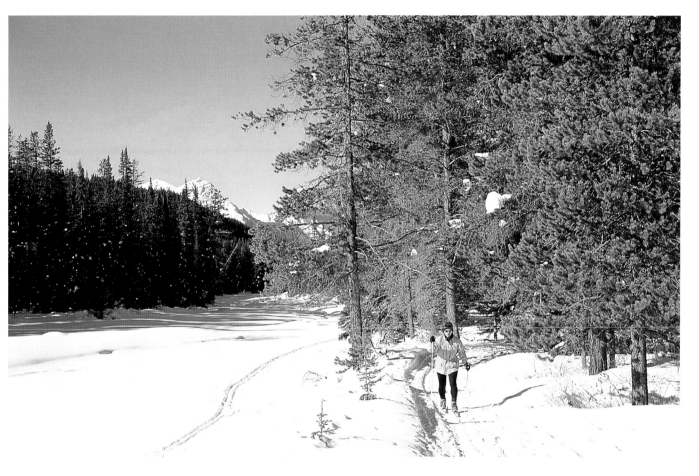

In 1909, long before the days of lifts and groomed runs, Austrian guide Conrad Kain led the first skiers to Lake Louise. Cross-country enthusiasts today can experience the same magnificent setting.

With its glowing woodstove, this cabin offers a cozy refuge from the harsh winter weather. While Banff National Park provides some of Canada's best recreation opportunities, snowshoers and skiers must be alert to the dangers of avalanche and hypothermia.

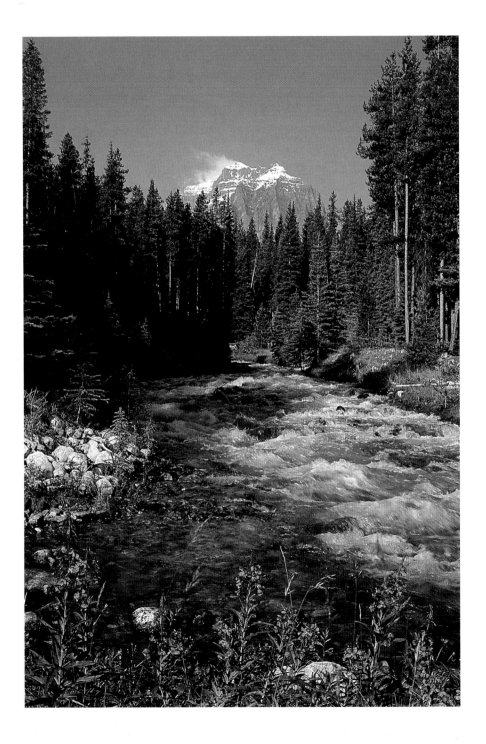

In the late 1800s, prospectors scoured the valleys of Banff National Park. Few signs now remain of Silver City, once a boomtown of 2,500 in the shadow of Castle Mountain. Bankhead, a nearby coal-mining town, was once larger than the town of Banff itself.

FACING PAGE—
Railway worker Tom Wilson became the first European to see Lake Louise, after a native guide brought him to the shores in 1882. Wilson christened it Emerald Lake, but the name was later changed to honour Queen Victoria's daughter, Louise Caroline Alberta.

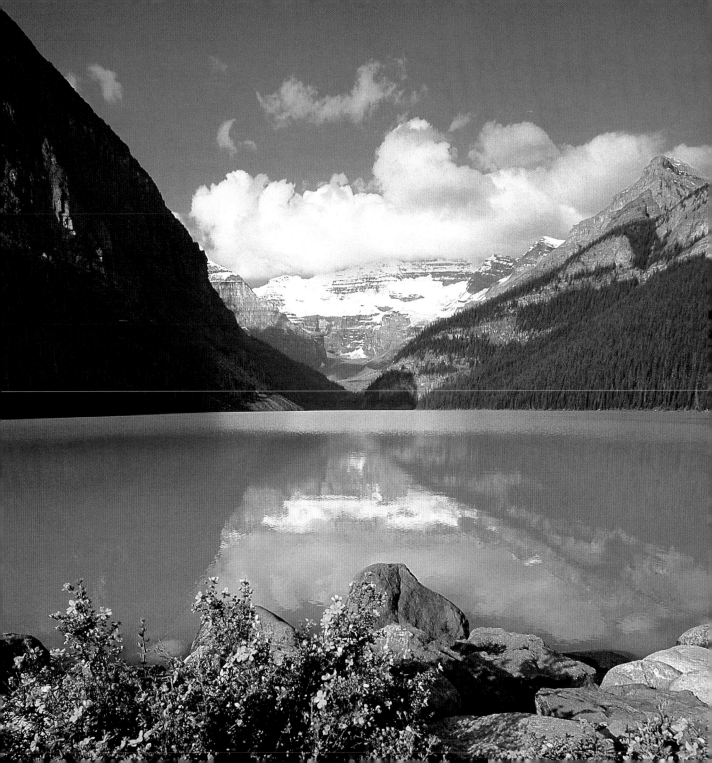

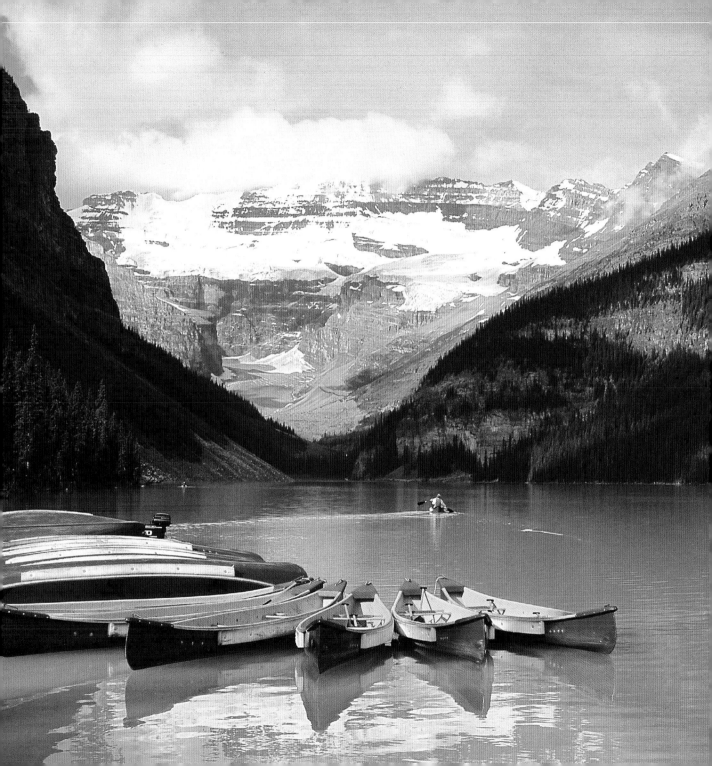

Rocky Mountains Park, established in 1887, originally encompassed 673 square kilometres (260 square miles) around Cave and Basin Hot Springs. The Lake Louise area was added to the park in 1892.

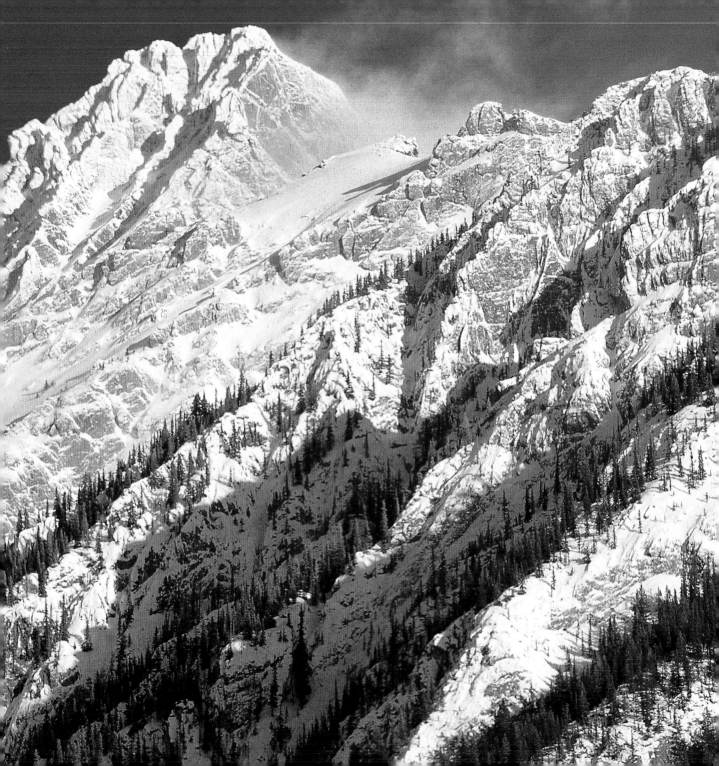

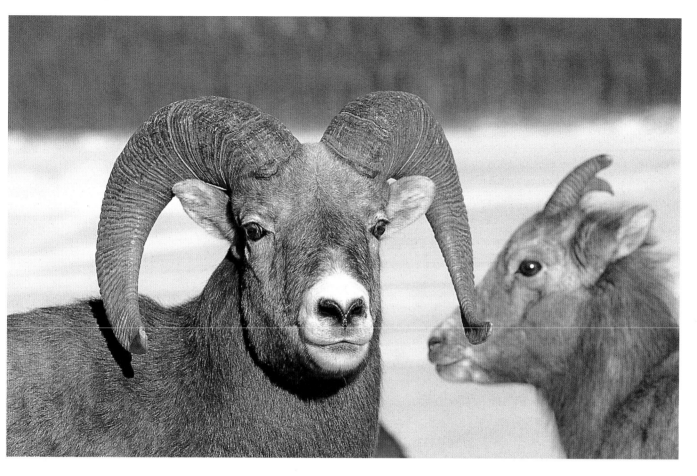

Highly adaptable, bighorn sheep can survive on the crags of the Rocky Mountains or below sea level in California's Death Valley. The male's twisted horns—the size of which often determines dominance—can weigh more than 13 kilograms (28 pounds).

The creatures of Banff National Park are uniquely adapted to the varied climate. Bears spend much of the winter in hibernation, bighorn sheep and elk migrate to the lowest valleys to forage for food, and tiny voles sculpt passageways through the snowdrifts.

Thirteen campgrounds and more than 2,000 campsites —from full-service RV sites with kitchen shelters and showers to backcountry tent pads—cater to Banff visitors.

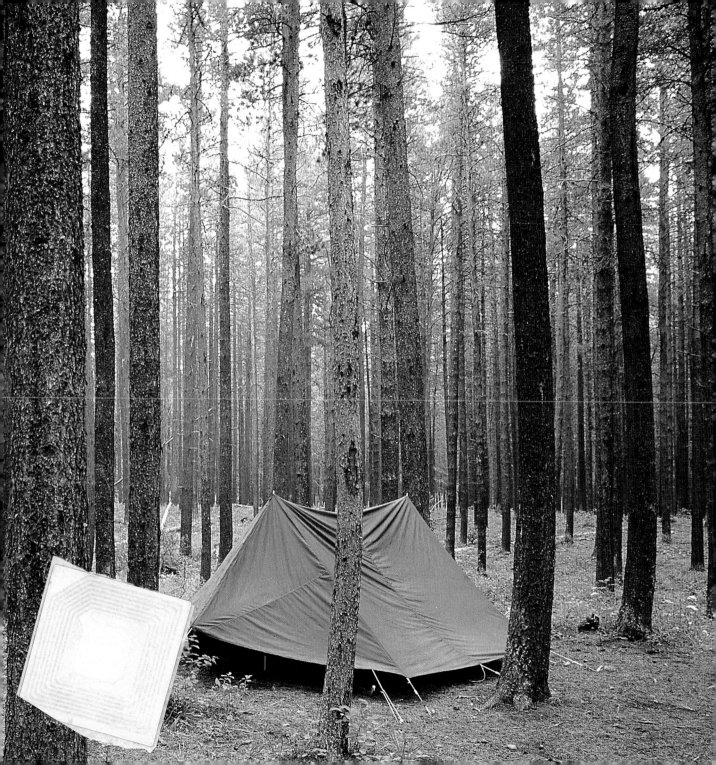

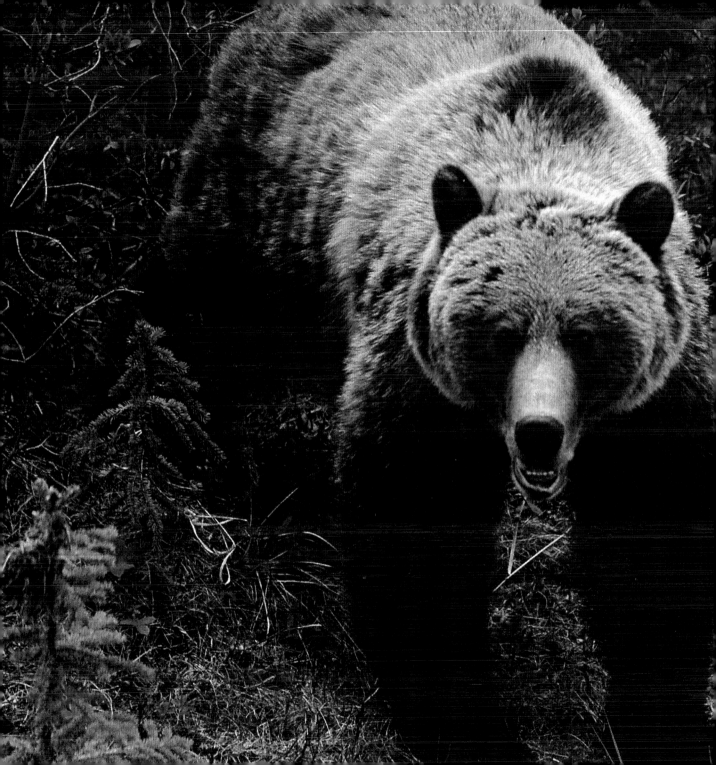

A male grizzly may wander a territory as big as 1,800 square kilometres (695 square miles). Females cover a smaller, but still impressive, area of 600 square kilometres (230 square miles) in their annual search for food.

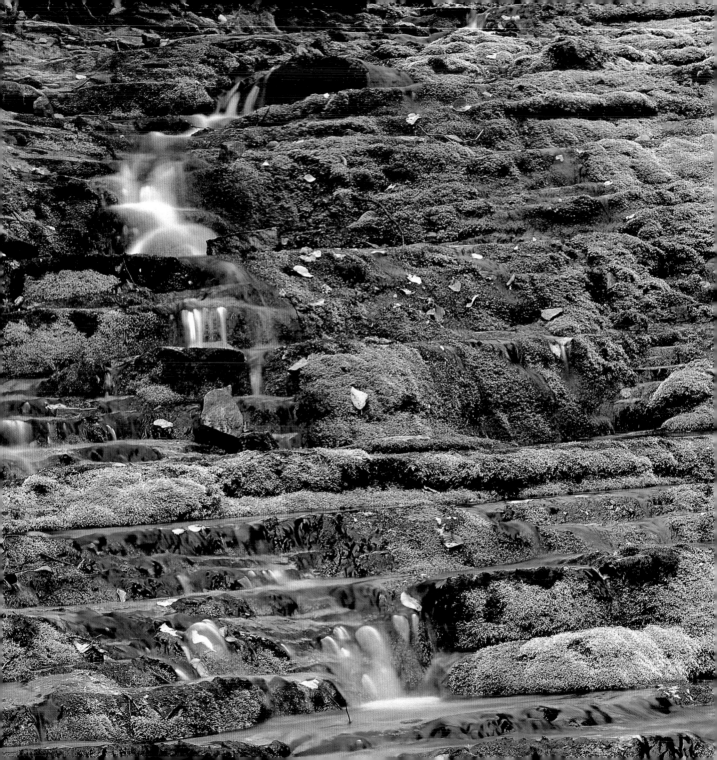

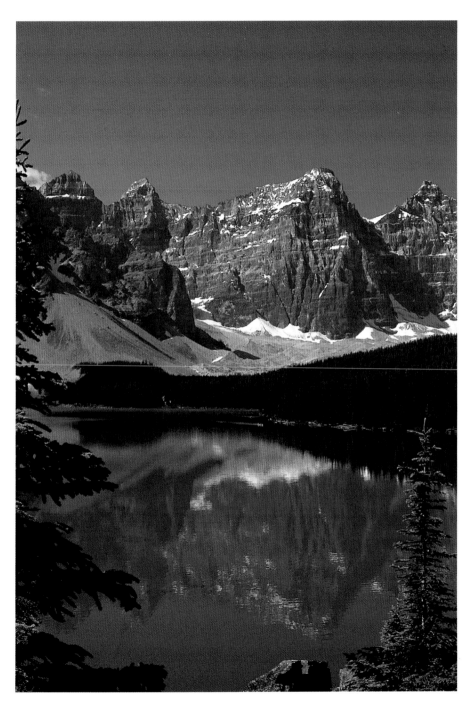

Yale student Walter Wilcox was the first white man to discover Moraine Lake, while searching for a new hiking route to Mount Temple in 1899. He wrote, "No scene has ever given me an equal impression of inspiring solitude and rugged grandeur."

Facing Page –
The glacier-carved slopes of Banff rise in a series of cliffs and basins from the valleys below. Over these slopes pour an infinite variety of waterfalls, changing daily with the levels of rainfall and glacier melt.

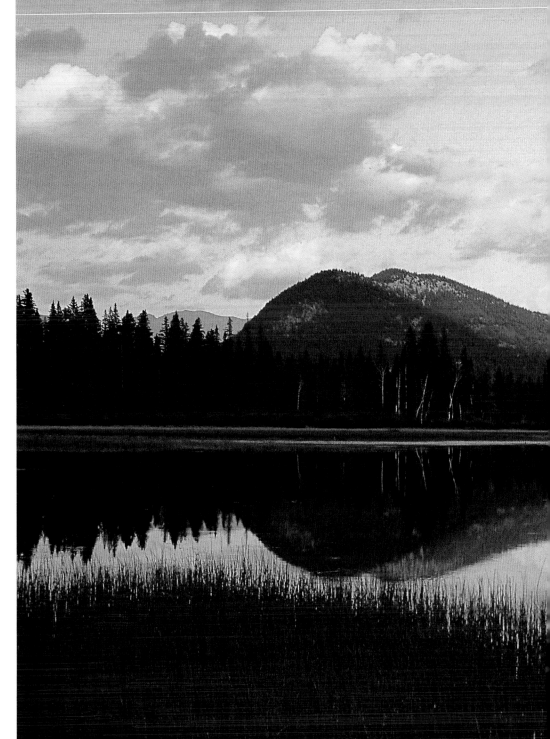

The Stoney guide who led explorer James Hector through the park spoke to him of a missionary, Mr. Rundle. Rundle had travelled the region years before, making his home in the valley below this peak. Hector named the peak Mount Rundle in his honour.

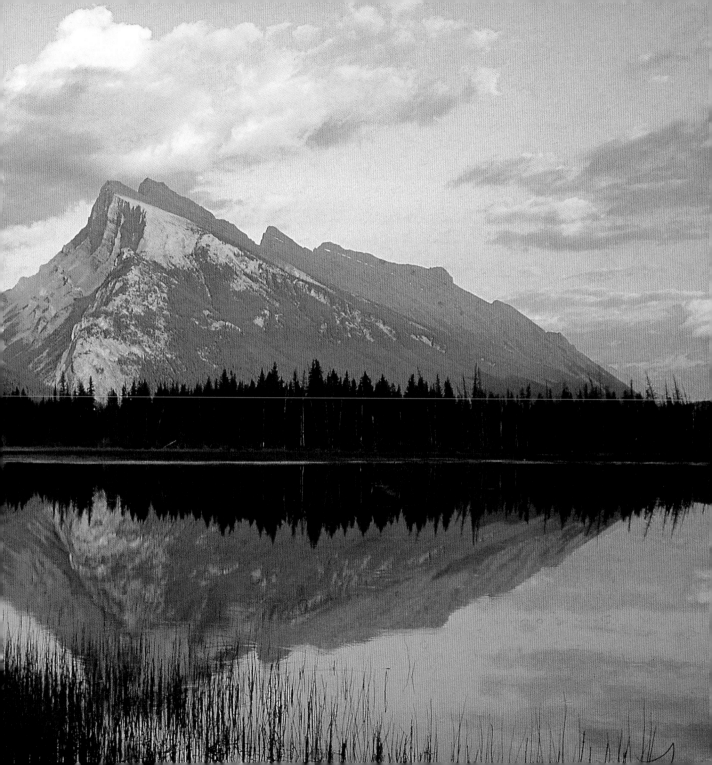

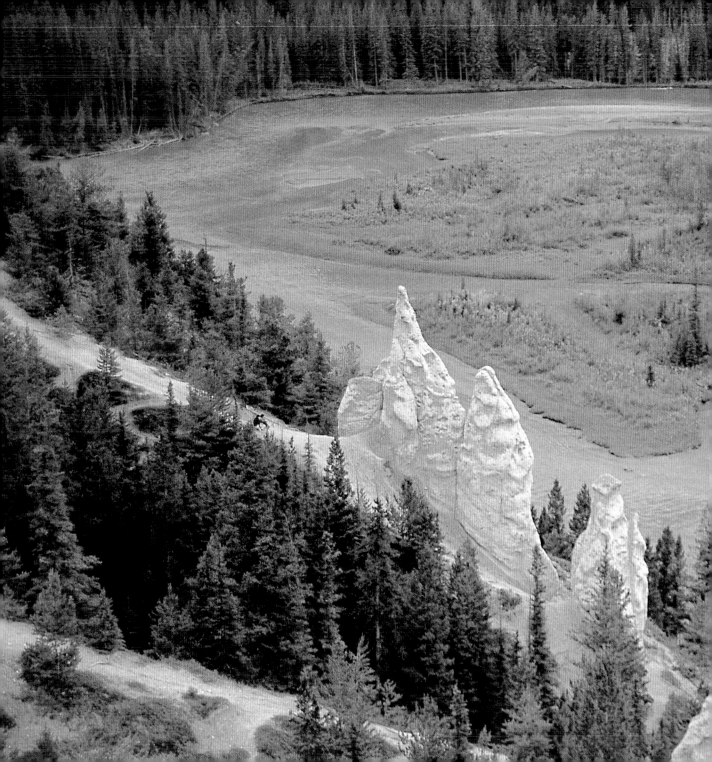

Photographed from a viewpoint along the Tunnel Mountain Road, these hoodoos rise like sentries over the Bow Valley. Hard deposits—sandstone, shale, or boulders— protected these landforms from erosion as the rest of the earth around them was swept away.

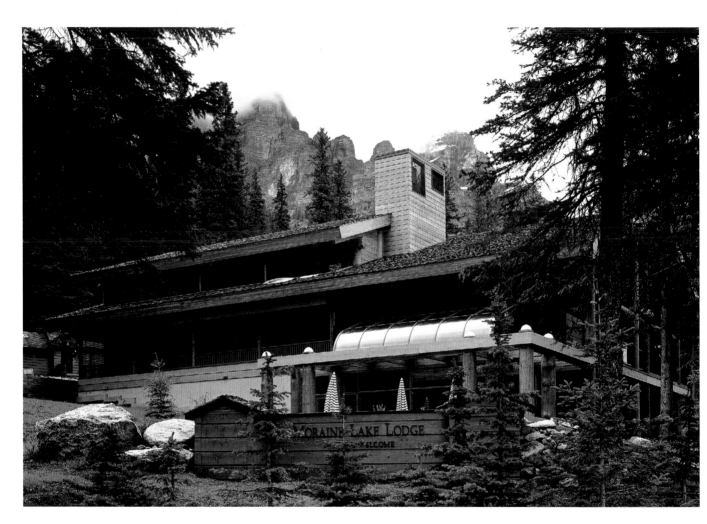

Eighteen cabins and a central, 65-seat dining room lure guests to
Moraine Lake Lodge, nestled within the Valley of the Ten Peaks. The
first lodge was built here in 1912, and the first cabins in the 1920s.

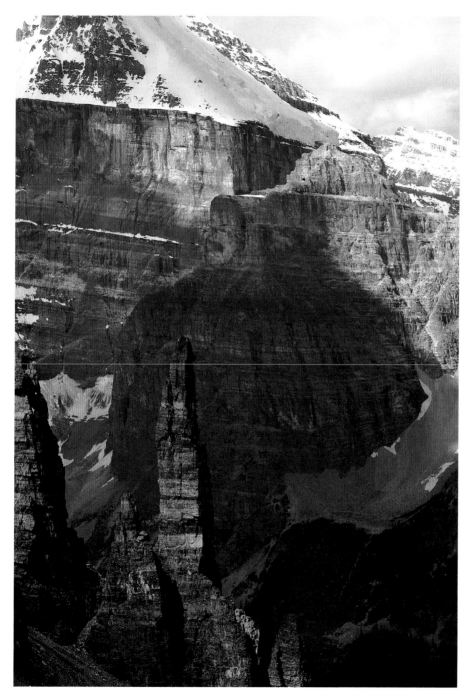

From the Paradise Valley loop or the trails above Moraine Lake, hardy hikers climb to Sentinel Pass, one of the highest accessible passes in Banff National Park at 2,611 metres (8,566 feet) above sea level.

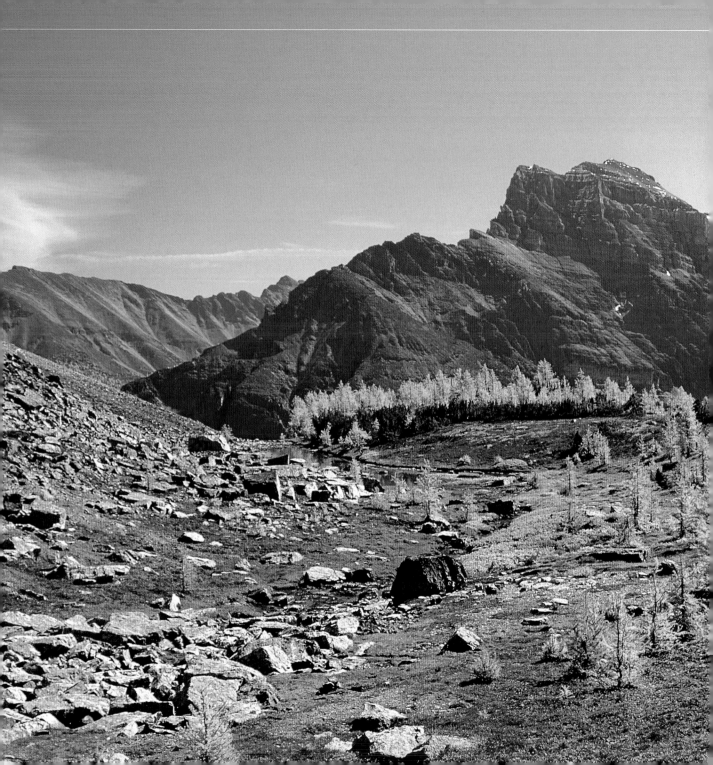

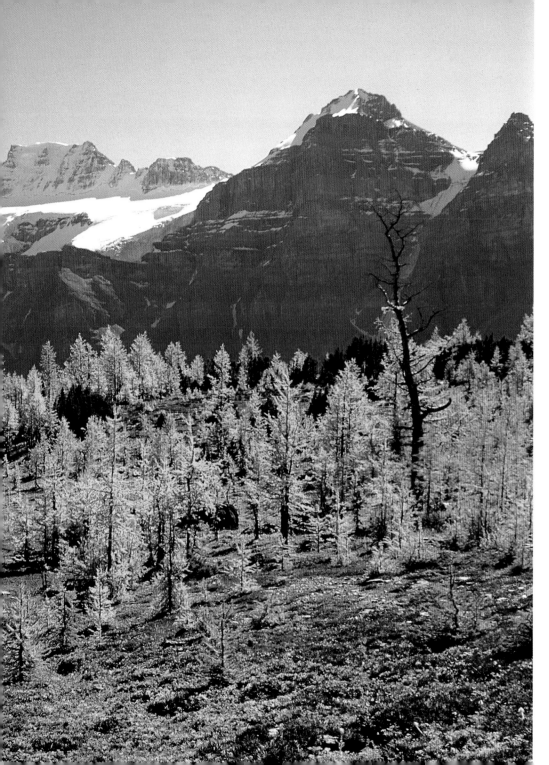

A steep two-hour trail from Moraine Lake reveals the golden fall colours of Larch Valley. Many valley landmarks, including the tiny Minnestimma, or "sleeping water" lakes, were named in the Stoney language by explorer Samuel Adam and his Stoney guide William Twin.

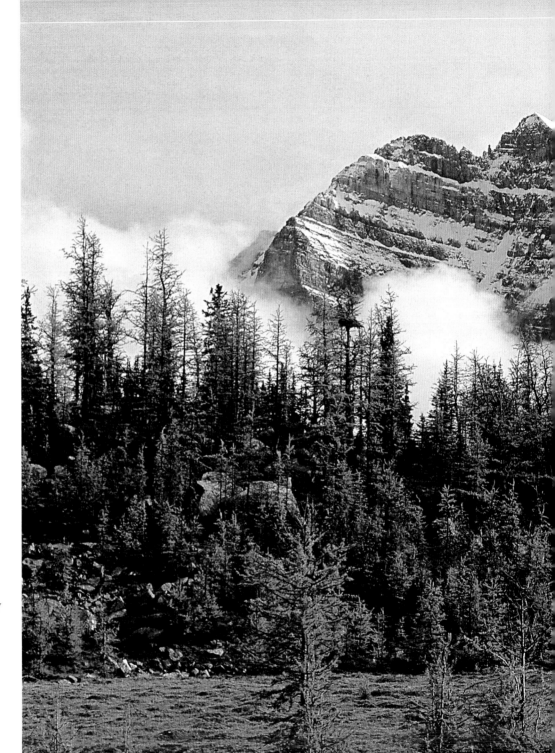

The highest peak in the Lake Louise area, Mount Temple was the first mountain over 3,300 metres (11,000 feet) high to be climbed by nineteenth-century mountaineers. Most of these mountain climbers were wealthy American or British men, led by experienced Swiss guides.

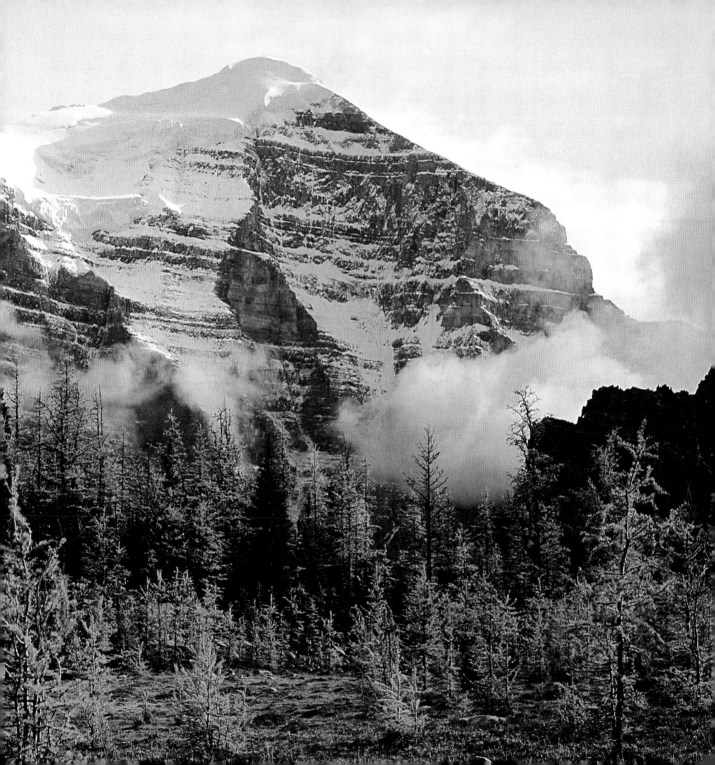

Lake Louise and Moraine Lake may be the best known, but there are 480 bodies of water within Banff National Park. From tranquil paddles on the Vermilion Lakes, just minutes from town, to more adventurous canoe circuits, the park offers a seemingly endless variety of routes.

FACING PAGE—
The park's largest natural body of water, Hector Lake is named for James Hector, who led the third group of the Palliser Expedition over Vermilion Pass. During his journey, Hector was the man kicked by a horse along what is now the Kicking Horse River.

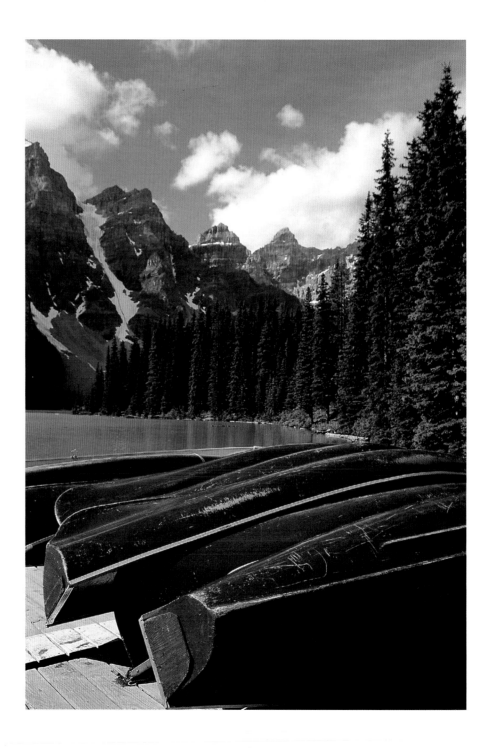

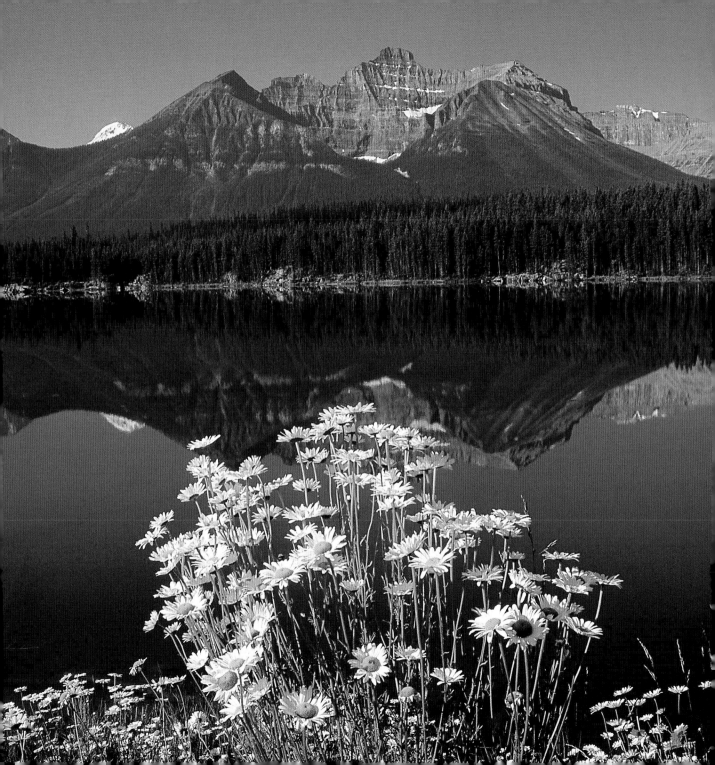

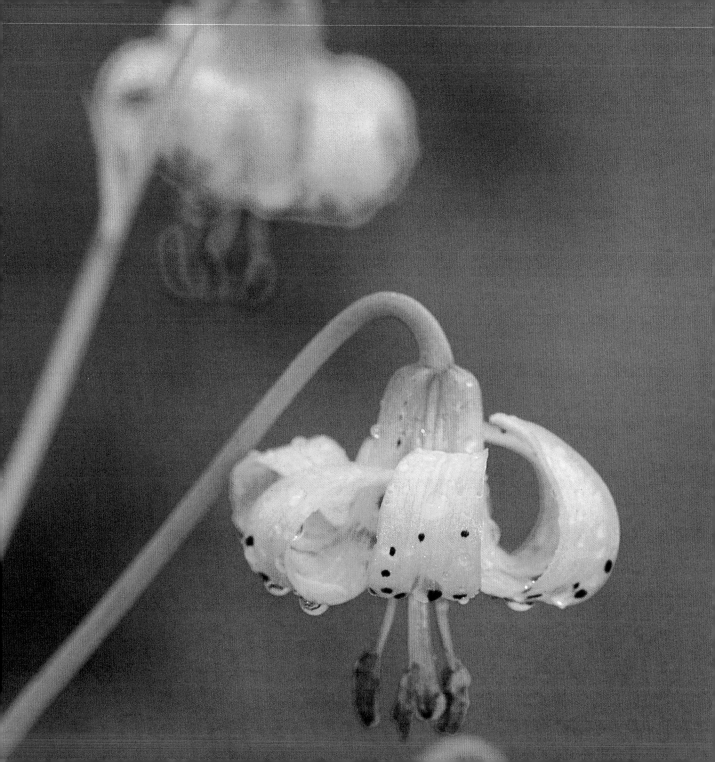

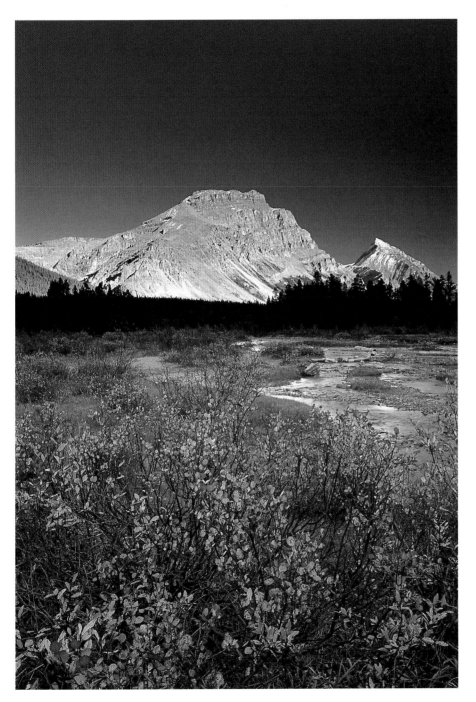

One of Banff's best-known events is the annual Mountain Film Festival, a celluloid celebration of the outdoors. Scenery such as this view of Mosquito Creek and Bow Peak serves as the backdrop to climbing adventure stories, extreme skiing films, and more.

FACING PAGE –
The nodding orange heads of the Columbia lily appear in the valleys and subalpine meadows of Banff each June. In full sun and moist soil, the plants can grow up to 60 centimetres (two feet) high.

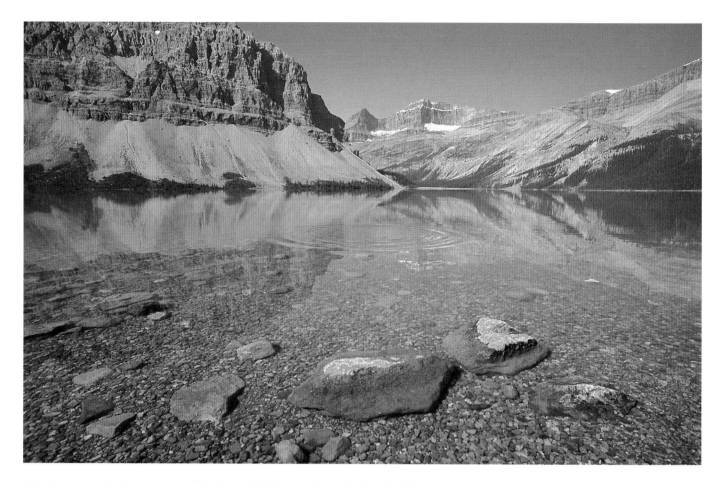

Environmental changes are affecting wildlife even in pristine Banff
National Park. Airborne pollutants are caught in the snowfalls of the
Rockies and transferred to the meltwater, contaminating the trout of
Bow Lake and other isolated water bodies.

In the early 1900s, mountaineering was the domain of men. Yet
two women were instrumental in the creation of the Alpine Club
of Canada. *Manitoba Free Press* editor J.W. Dafoe and journalist
Elizabeth Parker wrote a series of articles to support the club,
and helped organize the first meeting in 1906.

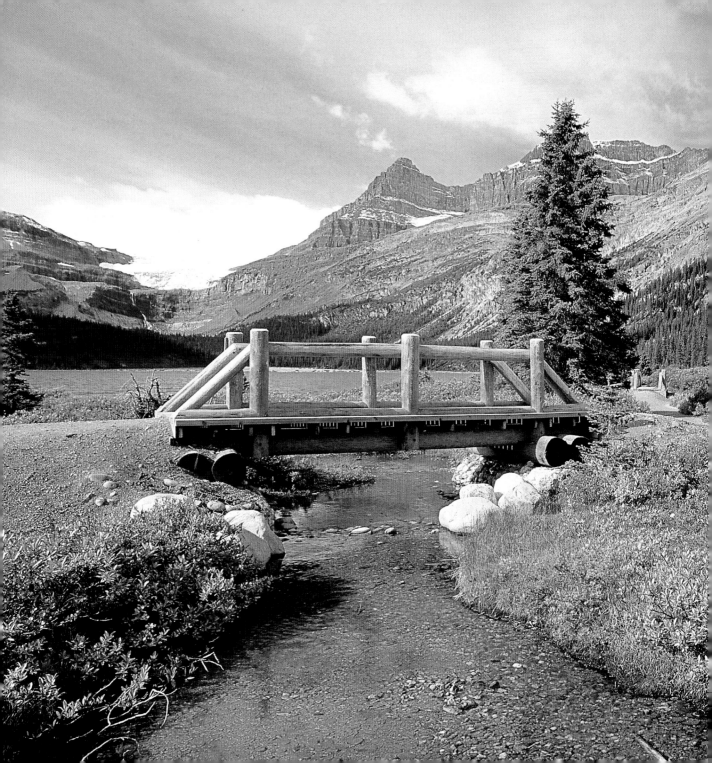

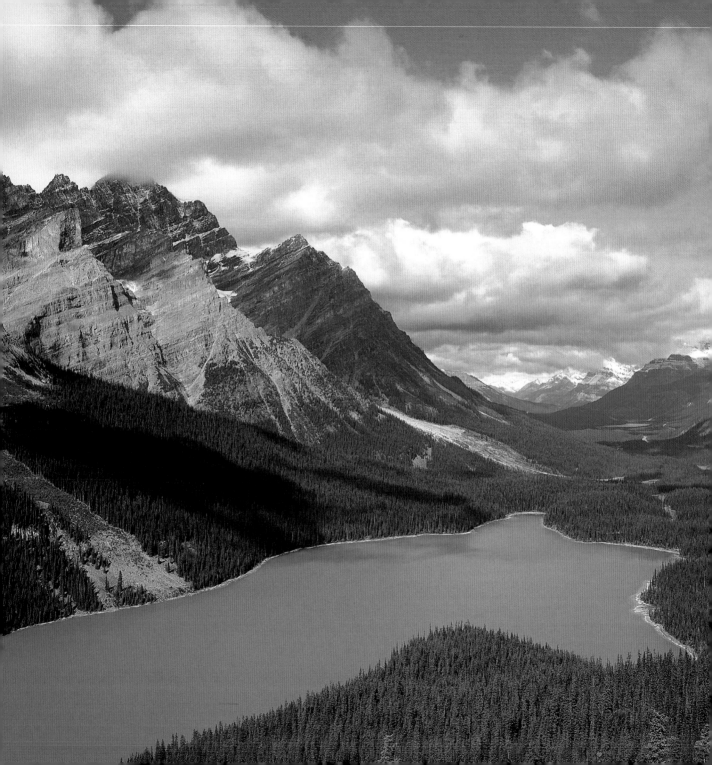

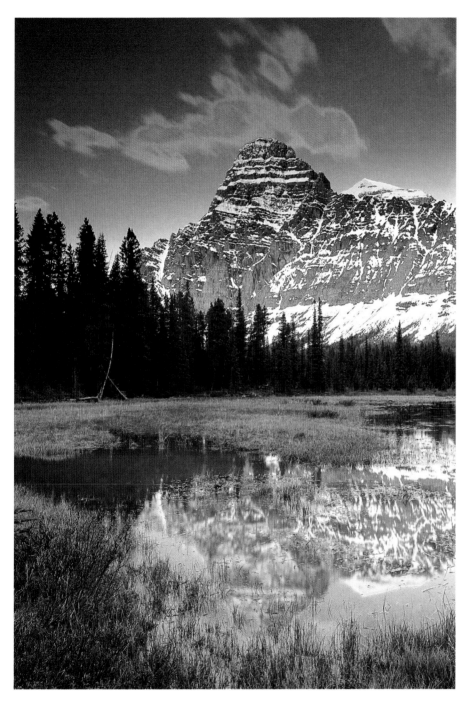

This view of the Mistaya Valley and Mount Chephren from the Icefields Parkway remains much the same as it was when First Nations traders followed this route. In the early 1900s, pack trains plodded for two weeks to reach Jasper National Park from Lake Louise. The first road between the parks was built in the 1930s, and the present highway was completed in the early 1960s.

FACING PAGE –
Peyto Lake, seen here from the Icefields Parkway, is named for one of the best-loved characters of Banff National Park. Ranger, guide, war veteran, and legendary eccentric Bill Peyto lived much of his life in the park. In 1894, he led the first successful climb of Mount Assiniboine.

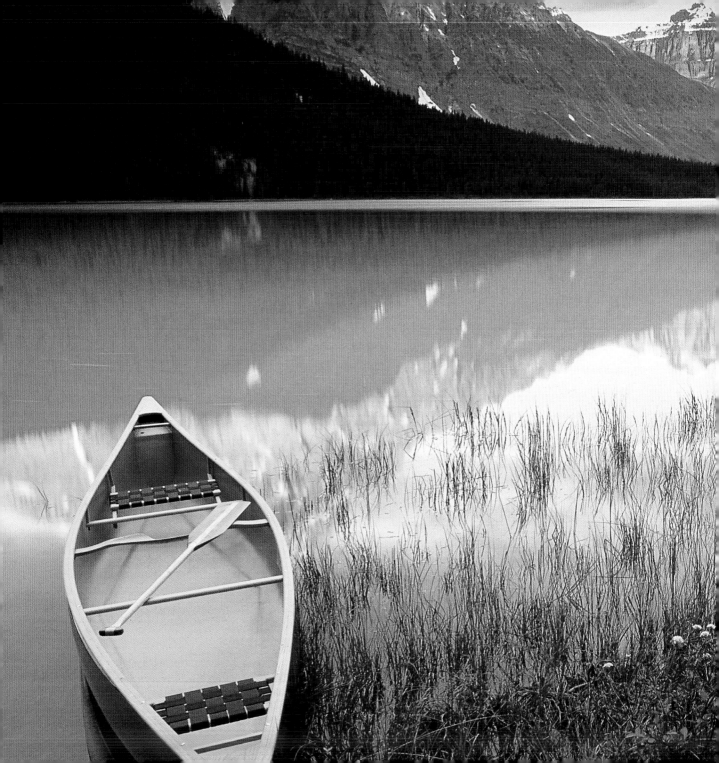

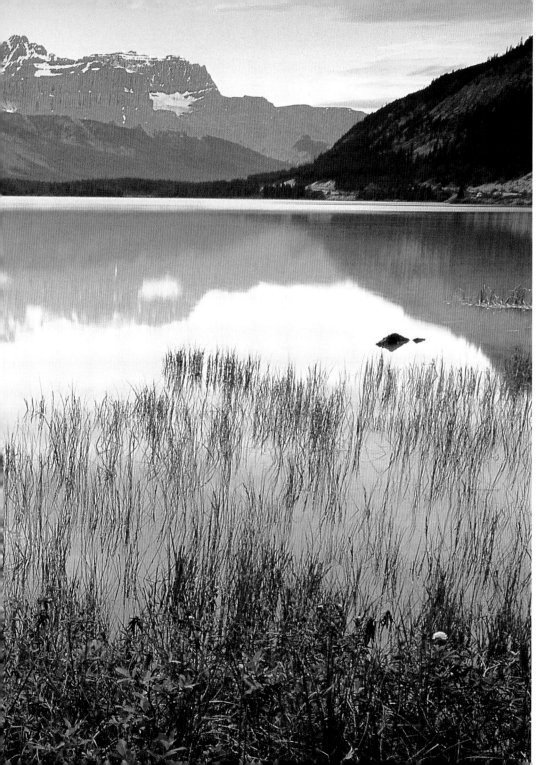

Paddling the still waters of Lower Waterfowl Lake in the early morning is the perfect way to sight many of the park's 260 bird species. Some of the most common waterfowl are mallards, green-winged teal, and Barrow's goldeneyes, which breed along the marshy edges of the lake.

Flowing from the north side of the Wilson Icefield into the North Saskatchewan River, Rampart Creek is typical of many that tumble down the slopes along the Icefields Parkway.

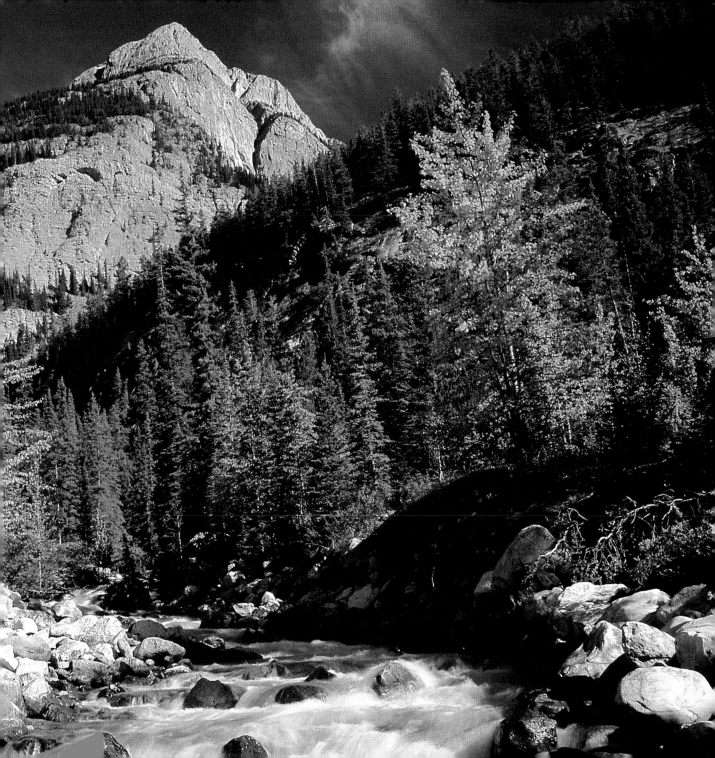

A sheer cliff of Palliser limestone, the Weeping Wall is named for the waterfalls that cascade from the edge. In winter, ice climbers scale a 160-metre (525-foot) lower climb and a more difficult 200-metre (655-foot) upper route.

FACING PAGE –
Campers at the Rampart Creek Campground are treated to spectacular mountain views. This 50-site facility is a common stop for visitors on their way from Banff to the Columbia Icefield in Jasper National Park.

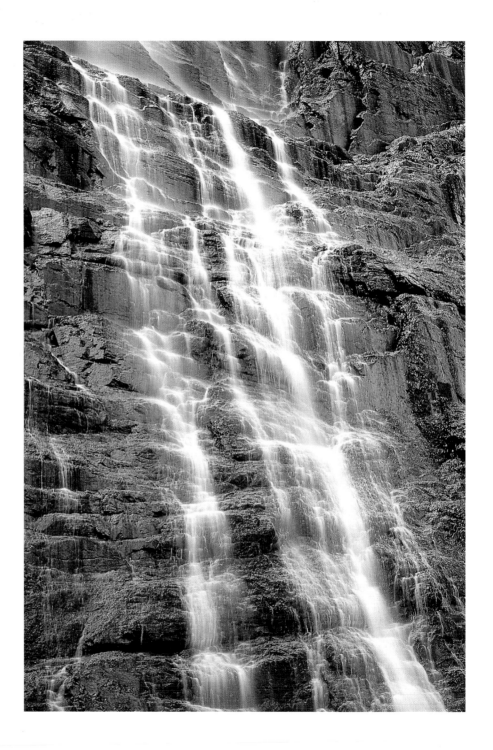

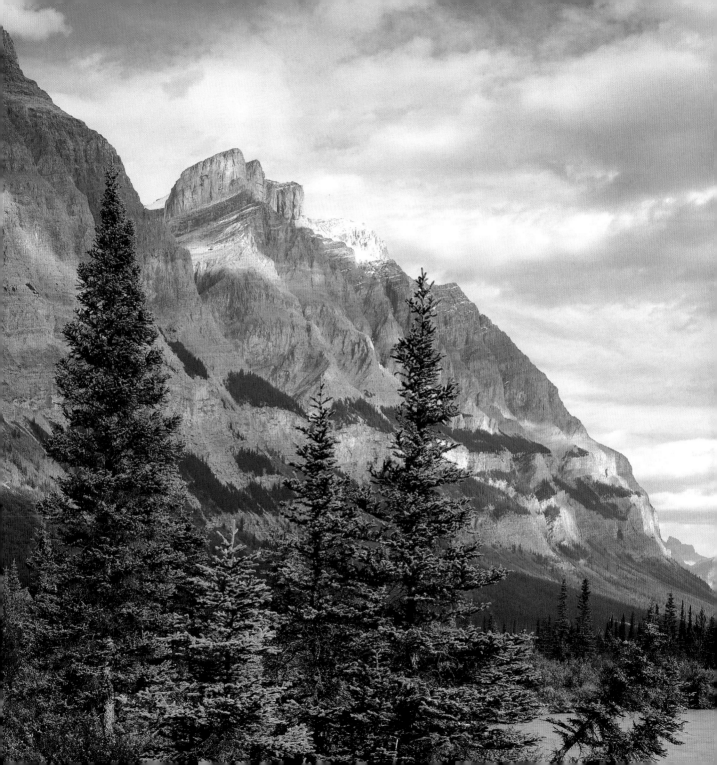

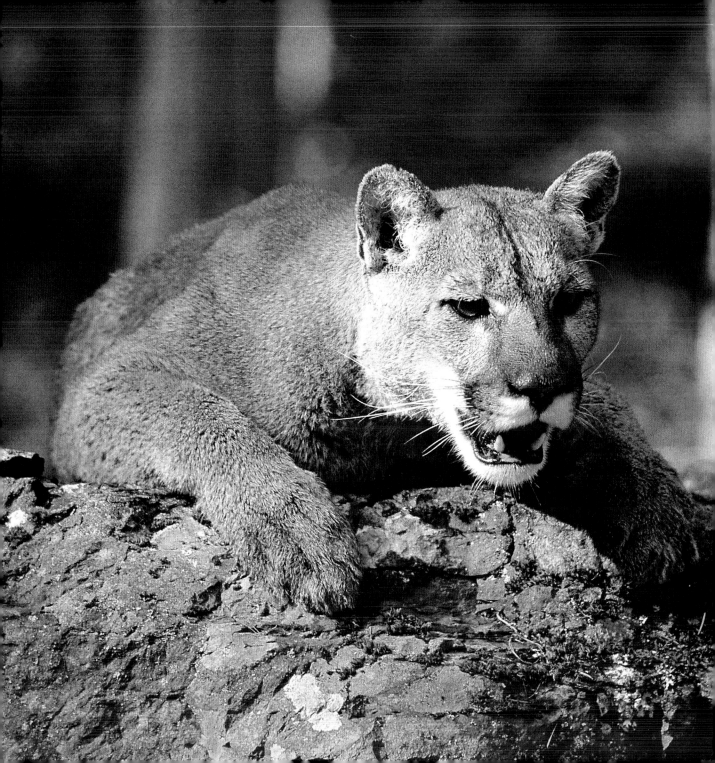

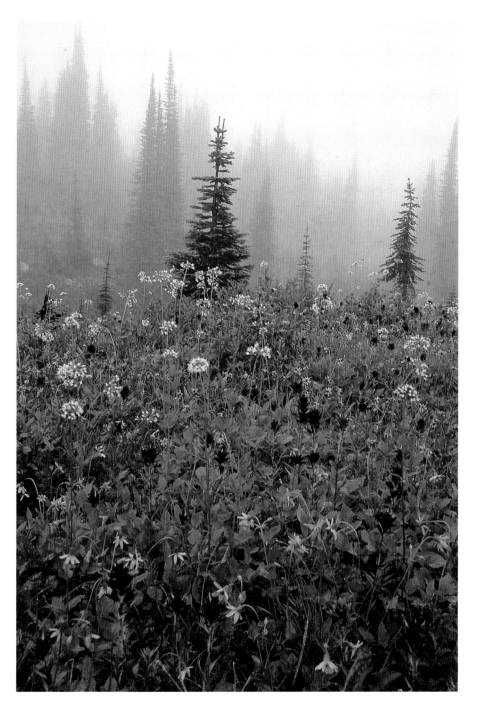

Archaeological sites within the park suggest that humans have inhabited these lakeshores and valleys for 11,000 years. When European explorers arrived less than two centuries ago, the most prominent First Nations were the Kootenay and the Blackfoot.

FACING PAGE —
Powerful forelegs, strong jaws, and long teeth help the cougar bring down prey much larger than itself. In the Rockies, the wild cats use the cover of the thick brush to stalk mule deer, white-tailed deer, young moose, elk, and even bighorn sheep.

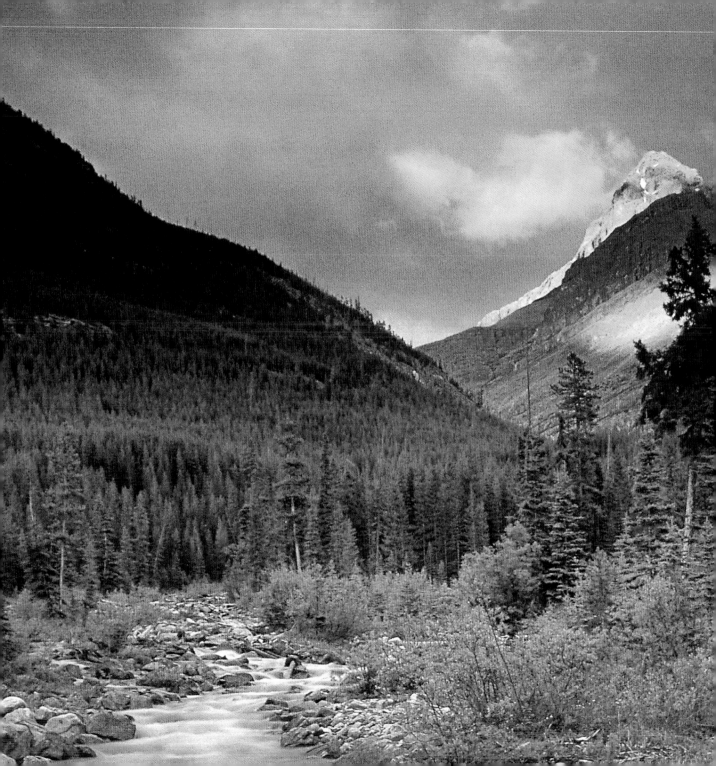

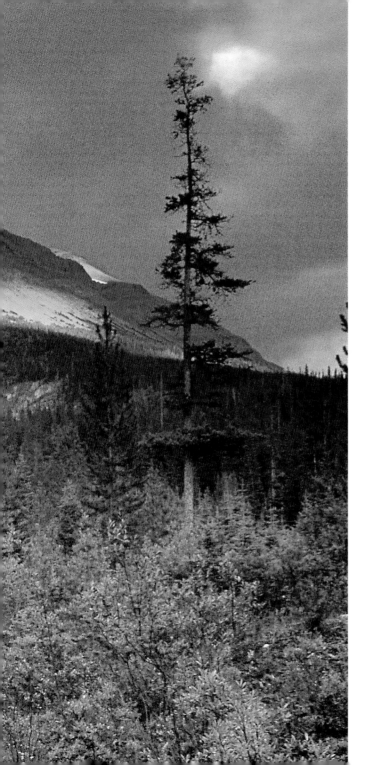

In the early 1800s, while David Thompson and Simon Fraser were trading in the Canadian Rockies, explorer Meriwether Lewis was forging a route across the same mountain range in what would become Montana. Lewis later travelled north through what is now Glacier National Park, almost to the 49th parallel.

Lake Louise, Sunshine Village, Banff Mount Norquay, Nakiska, and Fortress Mountain ski areas all wait less than an hour from the towns of Banff and Canmore. Cross-country enthusiasts enjoy the varied trails of the Canmore Nordic Centre, built for the 1988 Winter Olympics.

Facing Page—
Nestled just outside the borders of Banff National Park, the town of Canmore is surrounded by an outdoor playground. From the World Cup Mountain Bike Race each July to the Alberta International Dog Sled Classic held in January, there are sporting events for each season.

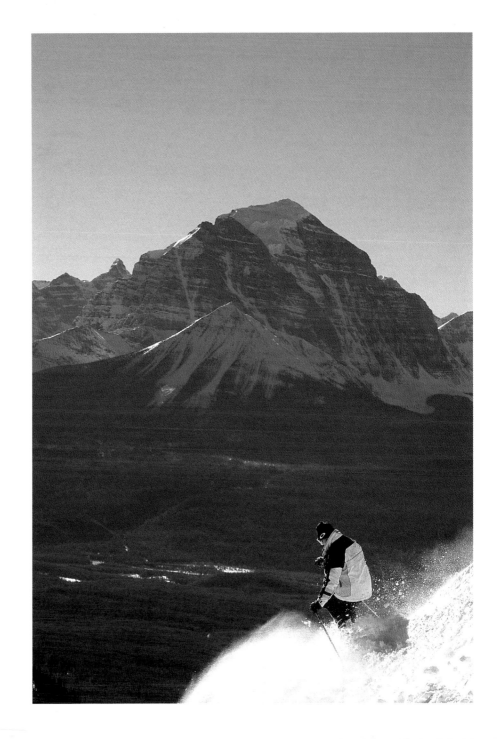

After the first car followed the railway tracks to Banff in 1904, the town promptly banned automobiles. The ban was short-lived, however, and most of the 5.5 million visitors who arrive annually to experience the mountain views travel by car.

FACING PAGE–
Air rising around mountain ridges—an effect known in scientific terms as orographic lifting—causes clouds to hang suspended around many of the park's highest peaks.

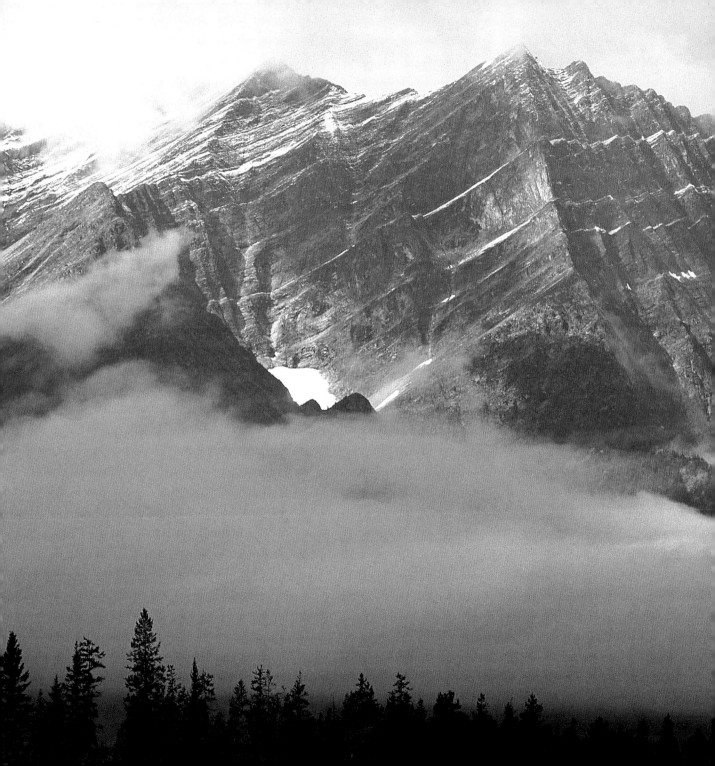

Photo Credits

Bob Herger 1, 3, 11, 12–13, 17, 21, 22, 23, 32, 35, 38–39, 52, 53,
54–55, 63, 64–65, 66–67, 74, 75, 78, 89, 95

Mike Grandmaison 6–7, 9, 10, 40–41, 46, 56, 57, 76, 84–85

Ian A. Ward/Lone Pine Photo 8

Laura Norris/Lone Pine Photo 14, 28

Gordon Hartley/Mach 2 Stock Exchange 15, 30–31, 33

Clarence W. Norris/Lone Pine Photo 16, 18–19, 20, 58–59

Darwin Wiggett 24–25, 37, 50, 62, 77, 81, 86, 90–91

Bev McMullen/Lone Pine Photo 26–27

Bill Marsh/Mach 2 Stock Exchange 29, 92

Michael E. Burch 34, 44–45, 47, 48–49, 72–73, 80, 94

Blake R. Hyde/Lone Pine Photo 36, 51

Leslie Degner 42, 60–61, 82–83, 88

Mark and Leslie Degner 43, 70–71, 79

James Burton/Mach 2 Stock Exchange 68, 69, 87

Helga Pattison/Mach 2 Stock Exchange 93